PRACTICAL CHINESE PAINTING
Colour Nature Essence

KNUSTON HALL

"To Knuston Hall, for providing the tranquil environment which not only inspired this book, but which enabled it to be completed."

PRACTICAL CHINESE PAINTING

Colour Nature Essence

Jean Long

BLANDFORD

First published in the UK 1988 by **Blandford Press**
An imprint of Cassell
Artillery House, Artillery Row, London SW1P IRT

Distributed in the United States by
Sterling Publishing Co, Inc,
2 Park Avenue, New York, NY 10016

Distributed in Australia by
Capricorn Link (Australia) Pty Ltd
PO Box 665, Lane Cove, NSW 2066

British Library Cataloguing in Publication Data

Long, Jean
 Practical Chinese painting : colour-nature-
 essence.
 1. Painting — Technique 2. Painting,
 Chinese
 I. Title
 751.42 ND1040

ISBN 0 7137 1983 4

Typeset by Asco Trade Typesetting Ltd, Hong Kong

Printed in Portugal by Printer Portuguesa.

Illustration (title page): *Hibiscus* by the author.

Contents

List of Photographs and Charts

The photographs in this book appear by kind permission of the British Museum.

The British Museum, Department of Oriental Antiquities, London WC1B 3DG.

The following charts from *The Chinese Theory of Art*, Lin Yutang, Heinemann Press, London 1967, appear:

The illustrations on pp. 12, and 43 are from *How to Paint the Chinese Way* by Jean Long, pub. Blandford Press 1979, pp. 16, 27, 36.

Introduction

To Western eyes most Chinese paintings seem to be very similar and lacking in originality. In fact, this is true. Chinese painters repeat the same themes over and over again, basing their interpretations on Master painters of the past. However, each interpretation is made original by nuances of difference, which are as clear to the Eastern eye as are the contrasts between Picasso or Rembrandt to the Westerner.

An analogy to music is most appropriate. The same piece of music can be brought to life by a skilful musician, or destroyed by an incompetent one. Chinese painting can be seen as a new interpretation of a well-known composition, brought to fruition by an accomplished artist. As with music, the artist must first master the technicalities of his media before he can achieve a polished interpretation.

The static culture of the Chinese has contributed in no small way to the continuity of traditional styles of painting, most importantly because until the twentieth-century evolvement of the fountain pen, and now the ball-point pen, everyone used a brush for writing and so had the basis of the technical skill which could be developed through calligraphy into painting.

The essence of Chinese painting is derived from nature. Topics such as flowers, birds, landscapes, insects and fish abound. Most paintings are simple in subject matter – a bird sitting on the branch of a tree; an insect poised to alight on a flower. These subjects are not painted outside in the real world but derive from concepts of them held in the artist's mind. A great deal of contemplation of the everchanging panorama of nature is necessary to achieve such a clear visual picture that, almost without conscious volition, the brush can convey these mind pictures on to the painting surface.

The western artist usually brings his or her painting subject into the studio to observe in close detail while painting, or sits outside, sketch book in hand, to convey the form onto paper, but the Chinese artist does not work in this way because the object is not to portray a realistic or even a naturalistic image, but to show in symbolic form, the essence of the subject.

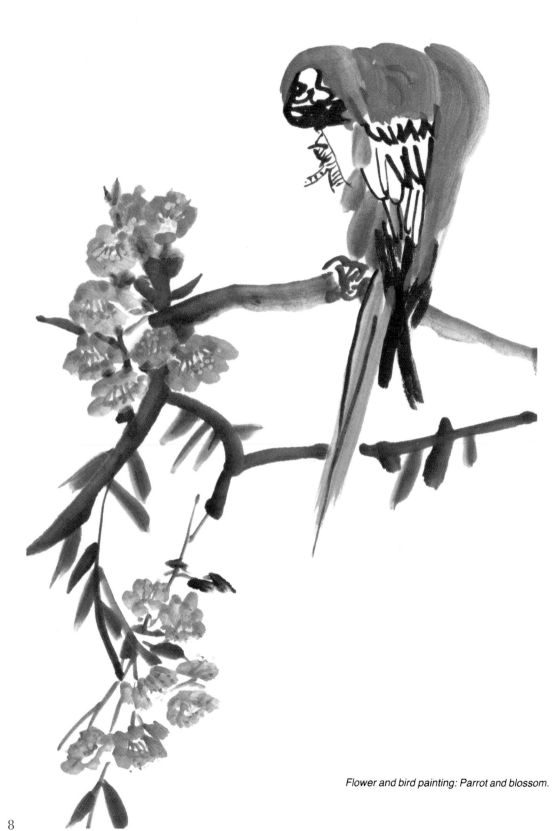

Flower and bird painting: Parrot and blossom.

1 Colour

There have been long periods of time during the development of Chinese painting when colour was regarded as superficial and much to be avoided, as philosopher painters searched for calmness and detachment in their painting. The belief that the inner essence and spirit of objects could be rendered more clearly in shades of black, undistracted by colour, was a result of the close alliance of painting to calligraphy.

Philosophers commented adversely on colour in everyday life, Confucius complaining that the purples and mixed reds of the court robes were decadent and Lao Tsu writing in the *Tao Te Ching* that 'the Five Colours will blind the eye'.

The Chinese language not only has few words to distinguish specific colours but the written word for colour itself '*se*' also means beauty, passion, anger and lewdness.

However, nearly half of all Chinese paintings use some colour in addition to black, and some historic painting periods are particularly noted for colour. Before the Sung period, the use of bright colours was quite common, and an early descriptive term for painting was *tan Ch'ing* (the reds and blues). During the T'ang period (AD 618–906), landscapes in blue and green were so popular that this kind of painting has become inextricably linked with thoughts of that time.

Later painters described their compositions as having 'ink and light colour' especially where this applied to small or large colour washes. Flower and Bird painters used colour more extensively, particularly if they were employing the 'one-stroke' technique.

COLOUR SYMBOLISM

Colour symbolism associated the Five Colours with the Five Points of the Compass and the symbolic Chinese creatures which rule the heavens, each of which is associated with a magic number, as well as with the Five Elements, the Five Ch'i (the atmospheric elements) and the Five Planets. The Five Tastes, the Five Organs and the Five Sounds were also connected with corresponding colours.

Chart showing the colour associations

Colour	Compass Points	Supernatural Creatures	Numbers	Elements	Planets	Seasons	Metal
BLACK	North	tortoise or snake	6	water	Mercury	winter	iron
RED	South	phoenix	7	fire	Mars	summer	copper
GREEN	East	blue/green dragon	8	wood	Jupiter	spring	lead
WHITE	West	tiger	9	metal	Venus	autumn	silver
YELLOW	Centre	yellow dragon	5	earth	Saturn		gold

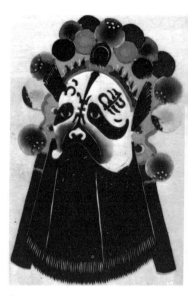

Colours can also be symbolic of rank, authority, virtues and vices, joys and sorrows.

Red	joy and all festive occasions, visiting cards
Yellow	the National colour, sacred to the Emperor and his sons
Blue	for high officials' sedan chairs (green for lower officials)
White	for mourning
Black	for evil
Vermilion	for the Emperor's special edicts
Mauve	for seals of the highest authority

Papercuts of stage masks showing different make-ups.

In Buddhism, the gods are white, goblins are red and devils are black, while yellow is the colour used for the priestly robes.

The origin of the red paper scrolls which hang in pairs to protect the home is a development of a legend with similarities to the Jewish Passover. Lamb's blood was used to smear the door lintels to represent the New Year sacrifice to Heaven. Charms against evil spirits were written on yellow paper.

Certain colours were used as royal colours for dynasties: Southern Sung (AD 960–1126) was brown; Ming (AD 1368–1644) was green; Ch'ing (AD 1644–1911) was yellow.

In the theatre, stage make-up designated the characters of the players: red for a sacred person, black for honesty, white for a cunning person, though one with dignity, while a low comedian had a white nose only.

The Republican Flag of China had five colours for the five races of China: Red for Manchurians, Yellow for Chinese, blue for Mongolians, white for Mohammedans and black for Tibetans.

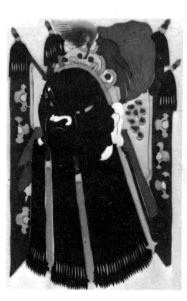

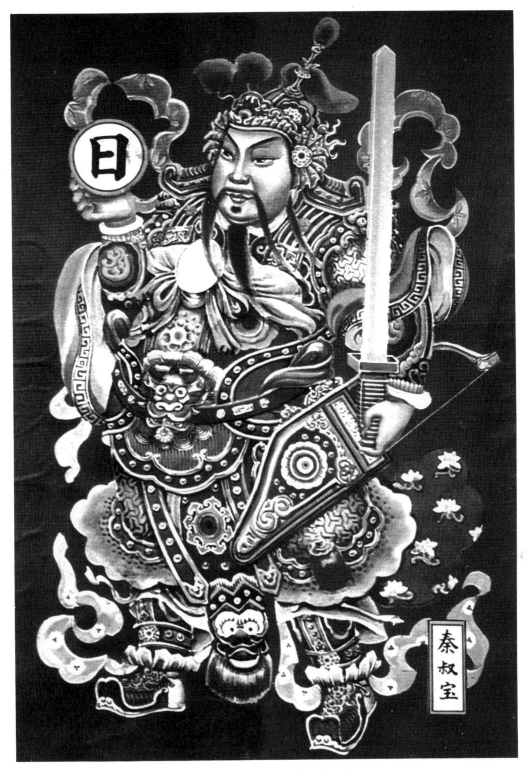

Red paper sign for door. Photo(s) by Xie Jun, Zhou Youma and Huo Jianying

Red and black have always been the most important of the Five Colours as their association is with the Primary Elements of Fire and Water, with Heaven and Earth and with Yang and Yin. They, as with the other three colours, were believed to have magical powers associated with Taoist alchemy. This is not surprising in view of the original methods of pigment preparation, which were prepared in secrecy with incantations.

Chinese black ink is prepared from pine soot which is then mixed with glue, pressed into moulds and dried to form ink sticks or ink cakes. When it is needed for painting, the ink stick is ground with water on a flat ink stone to make the black ink. The other four colours were originally either of mineral or vegetable origin and were ground in a bowl with water or glue added to required consistency.

Colours from vegetable and mineral sources

Colours	Mineral	Vegetable
blues/greens	azurite, malachite	indigo
reds	iron oxides, orpiment, coral	cinnebar, a red-leaved vine
yellow	iron oxide	sap of the rattan plant
white	lead	crushed oyster or clam shells

Another kind of ink stone.

Different ink sticks.

Old manuals give surprising hints for painters in their use of colour. The juice of an apricot seed can be used to wipe painted white clean if it has darkened, they say. Or a little ear wax added to mineral blue or ink which is grainy will help to improve the consistency.

COLOUR MIXING CHART

Yellow and blue = green
Crimson and blue = purple
Yellow and red = brown

The above are three basic combinations of yellow, blue and red, but the proportions in which these colours are mixed, together with the additional shade combinations available from adding white or black are described in the following chart:

Table of colour mixing

Colour obtained	crimson	vermilion	Basic Colours sky blue/ indigo	white	yellow/ gamboge	black ink
pink	3 parts			7 parts		
gold red	2	2			1	
purple	5		4			
violet	3		6			1
sap green			1		1	
deep green			3		2	
light green			3		7	
inky green			4		3	3
inky blue			7			3
gold yellow	1	2			7	
old red		1			1	1
sandal-wood		3			5	1
umber		3			3	1

Colours can be accurately mixed in a saucer by adding the measured water colours from a small spoon, but it is often better to let the two or three colours blend naturally on the paper.

Colour chart.

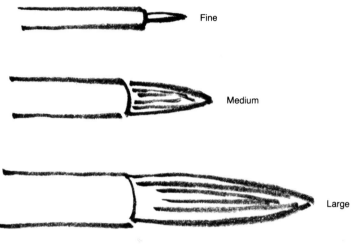

Fine

Medium

Large

Actual brush sizes.

The peacock is a favourite subject for Chinese painters.

BRUSHES

Instructions for the paintings in this book describe the brushes needed as being either fine, medium or large. Many brushes have numbers on them, but these numbers vary from brush manufacturer to brush manufacturer. All the paintings in this book have been achieved using one of the three following sized brushes. In fact, most of the basic compositions could be painted with the medium brush only, once control of the point has been achieved. Practice will demonstrate how easy it is to use these Chinese brushes with control and variety.

COLOUR USES

Young grass in spring is conveyed by greens and blues, while different combinations of these two colours produce the shades of thick summer grass. In autumn the grass withers and yellow and brown are the colours to be mixed to convey this seasonal change.

Mountain birds, living in the trees, require all five colours for their plumage. The phoenix and the pheasant have red and green feathers. Clear colours, since they are continually bathing in the flowing streams, are used for water birds, which should be painted in blues and greens – unless, like the female mandarin duck or the kingfisher, they need all five colours to convey the brilliance of their plumage.

The following list indicates some traditional uses for the colours, not necessarily in their pure form, but in shades and tones as appropriate.

crimson	flowers, figures, sky
vermilion	flowers, men's clothes, leaves, pagodas, temples, figures, camellia, lotus, maple, tallow tree, persimmon, chestnut
yellow	flowers, landscape, leaves in autumn, clothing, some pine tree bark, mountain slopes and paths
blue	clothes (dark), landscape (light), dotting leaves, back of paintings, flowers
white	figures
green	landscape, trees

SHADES OF BLUE

There are two basic kinds of Chinese pigment colours – mineral and vegetable. Azurite blue is a mineral colour and indigo is a vegetable pigment.

Hydrangea on silk, painted by the author. The fan-shaped format is a very popular one. In this case the shape has been cut out in mounting card and the silk mounted behind it. The silk painting can be used as a window picture, where because the painting has no backing, light will be able to shine through the material and the colours will have an additional glow.

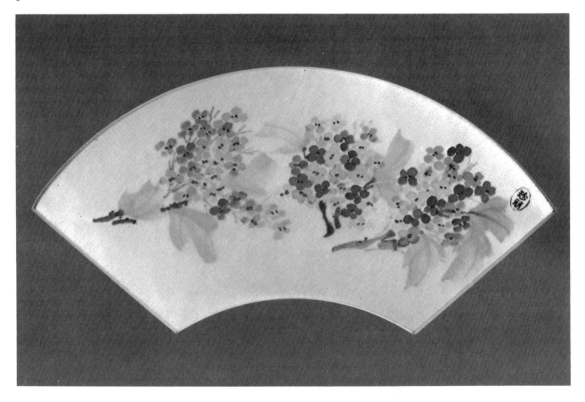

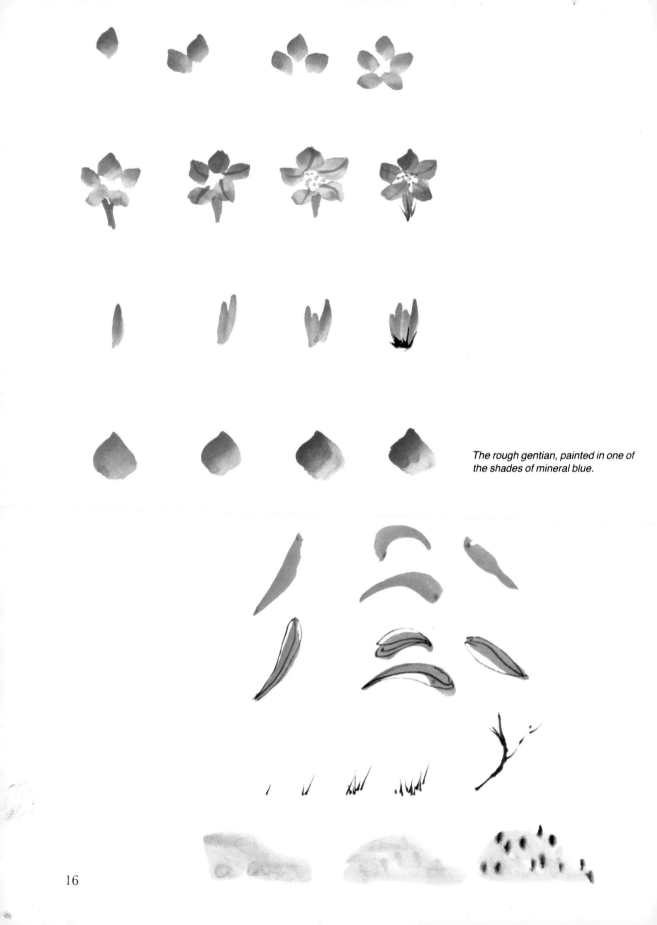

The rough gentian, painted in one of the shades of mineral blue.

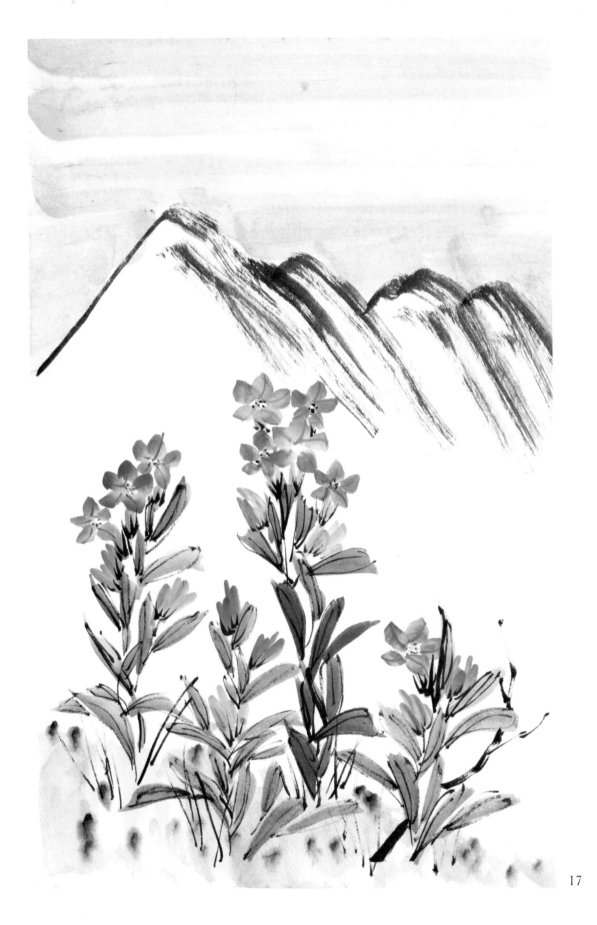

Teasel heads – indigo and browns mixed wetly and allowed to run on absorbent rice paper.

Mineral Blue (sometimes called *shih ch'ing*, or azurite, approx. = Ultramarine)

It is used in three shades:

> *Light and clear* for the faces of leaves and for landscapes;
> *Medium* for blue flowers, for accentuating the heads and backs of birds, for dotting between leaves or for washes on the backs of paintings;
> *Dark* for garments in figure painting, for touches on leaves and for accents on the wings and the tails of birds.

Indigo Blue (*tien hua*)

This is used for stronger touches on birds and flowers and for distant mountains and for outlining or the veins on leaves.

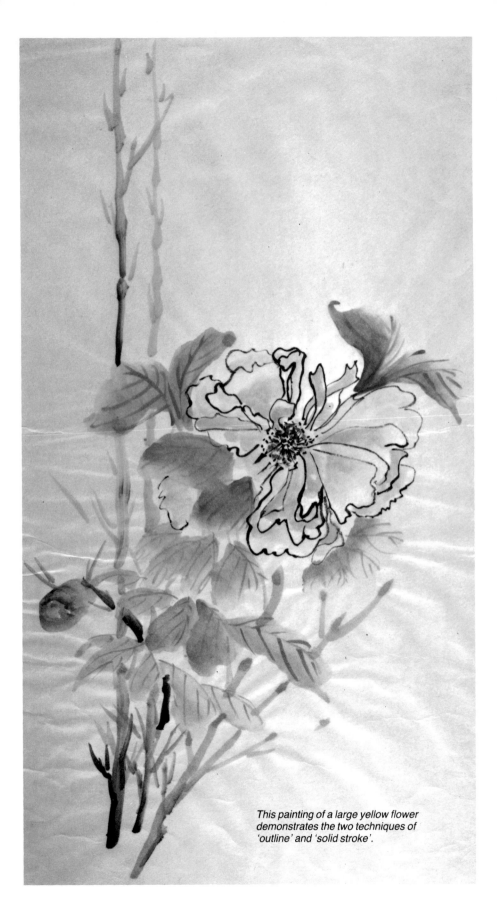

This painting of a large yellow flower demonstrates the two techniques of 'outline' and 'solid stroke'.

19

Mixing the Blues

For flowers a touch of red can be added to the Mineral Blue.

Indigo can be added to green for birds such as the kingfisher.

Indigo added to greens enhances the reds and pinks of the nearby flowers and so they complement each other.

Indigo with red produces Lotus Green (*lien ch'ing*).

Indigo and white produce the pale green where lotus roots join.

6 parts indigo and 4 parts vegetable yellow produce old Green (*Lao lu*).

3 parts indigo and 7 parts vegetable yellow produce young, fresh green (*man lu*).

'*Ch'ing ch'u yu lan*' – Chinese saying meaning,

'as green comes from blue and is superior to it'.

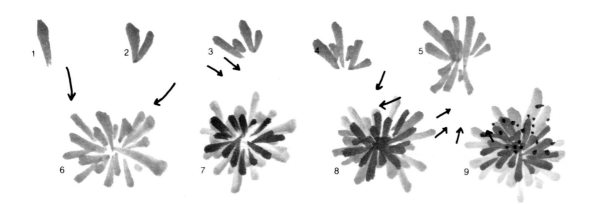

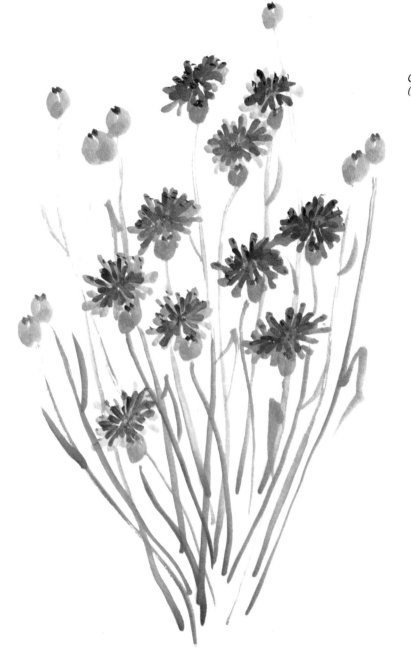

Cornflowers, painted by the author.
(p. 26)

有時三點雨點雨

到處十枝五枝花

Sometimes a flower painting can be enhanced by the addition of a piece of calligraphy, one of the most usual forms being that of the couplet.

From T.C. Lai's book *Chinese Couplets* a suitable one might be:

'Sometimes two or three drops of rain;
Everywhere five or ten sprigs of flowers.'

Blue Landscapes

There was a special kind of landscape, always painted in the blue-green style which was called *Ch'ing lu shan shui*, but perhaps more common in modern Chinese landscape painting is the 'Indigo-style' landscape.

Indigo-style landscape

Lightly wash umber over the basic ink structure with some indigo. Then sky and water are lightly washed in with indigo. (NB, small pieces of paper can be used as a blotter to absorb any surplus or excessive colour.) Finally the whole picture is given a delicate indigo wash. The colour, because it is transparent, serves to intensify and emphasise the original structural elements.

 Hsuan-jan are small areas of wash.

 Jan is the overall wash applied evenly to large areas of painting.

 '*Jan*' can cover '*Hsuan-jan*'.

PAINTING THE INDIGO LANDSCAPE

Colours: black, indigo, umber
Brushes: fine, medium, large
Steps: (Paint 1–8 in shades of black)
 1. (Medium brush) Paint rocks in pale black to give main landscape structure.
 2. Paint trees on Rock groups A and C: trunks with the medium brush and leaves with the fine brush.

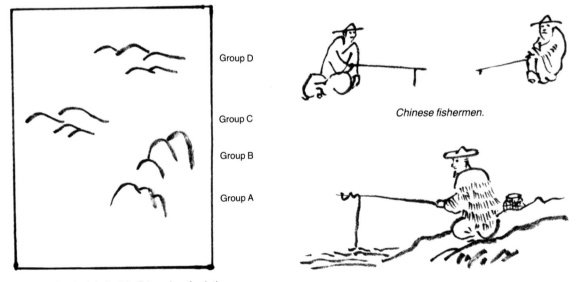

Group D

Group C

Group B

Group A

Chinese fishermen.

Groups of rocks labelled A–D in order of painting.

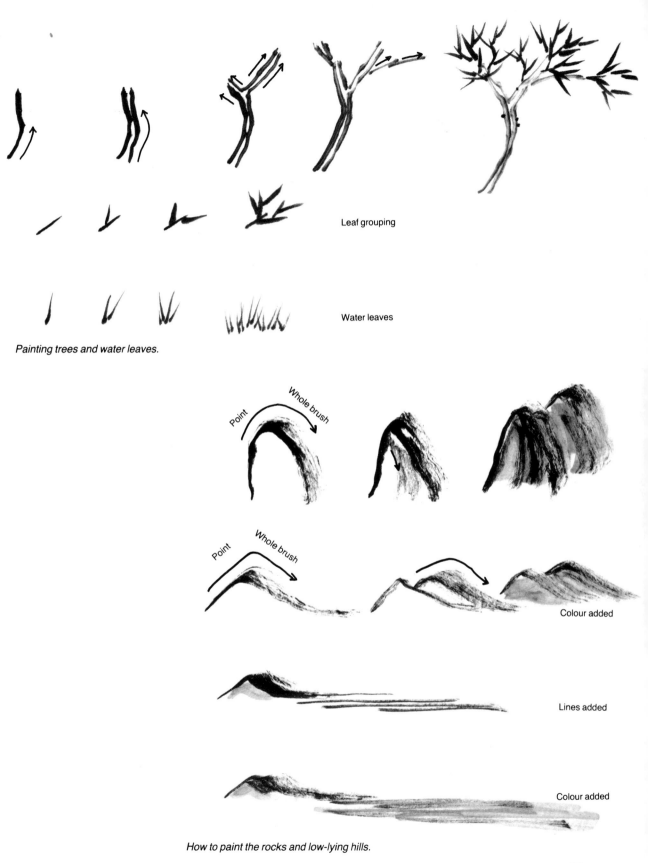

Leaf grouping

Water leaves

Painting trees and water leaves.

Point

Whole brush

Point

Whole brush

Colour added

Lines added

Colour added

How to paint the rocks and low-lying hills.

23

3. With a fine brush, paint the fisherman between Groups A and B.
4. Medium brush, dry black, add structure lines to all rock groups.
5. With the fine brush loaded with black, make flick strokes for water-growing leaves and some leaves on Group D rocks.
6. With medium brush, make individual black brush strokes on Group D.
7. With medium brush, paint grey and black horizontal water lines.

Calligraphic couplet for a blue landscape painting.

Boats and birds.

8. With fine brush loaded with black, paint boats and birds. All black and grey strokes should be completed before any colour is added.
9. With medium brush, add pale indigo lines to reinforce the water lines, with some umber lines.
10. With large brush, add small wash areas to rocks in pale umber and pale indigo.
 Allow painting to dry.
11. Use a large brush and after mixing enough pale indigo, paint a wash over the whole painting, either on the front or the back of the painting.
 Allow painting to dry lying flat on clean newspaper.

If suitable calligraphy is to be added to a painting, it should be completed before the addition of the all-over wash.

A suitable couplet might be:

'The azure sky mingles with the water
and the water joins with the sky –
sky and water in one colour;
The clear moon shines on the frost
and the frost reflects the moon –
moon and frost exchange brightness'

from T.C. Lai's *Chinese Couplets*

明月照霜宿照月宿月交輝

碧天連水水連天水天一色

The completed blue landscape.

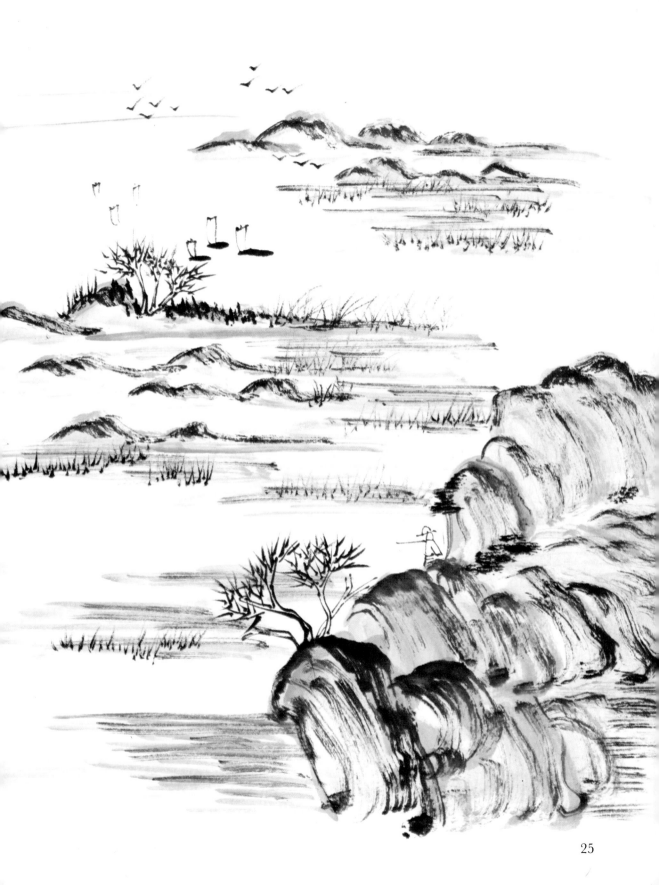

PAINTING CORNFLOWERS (see pp. 20, 21)

Colours: ultramarine, white, purple, green
Brushes: medium and fine
Steps:

 1–6. Using a medium brush, mix ultramarine and white and paint individual strokes to build up the base flower.

 7. With ultramarine only on the medium brush, paint a darker layer of strokes over the base flower.

 8. With medium brush, add green dots to the flower centres.

 9. With a fine brush, add purple dots to the centre and top of the flower.

 10. With medium brush loaded with green and white mixed, paint flower base and stem.

11–13. As on diagram.

 14. Add leaves and purple dots.

Paint the flowers first, then the buds, stems and finally the leaves. The stems cross each other, so the brush should not be too wet when painting them. Note that the stems are not lined up at the base.

PAINTING GENTIANS (see pp. 16, 17)

This flower originated in China and blossoms between August and September in central and north China, and between November and December in the south. It grows wild on slopes, under bushes and on the edges of forests, looking like ordinary grass until the little bell-shaped flowers burst out. It is a perennial herb with single oval leaves opposite each other. The root contains medicinal elements which are used to relieve stomach pains, fevers and rheumatic problems.

Colours:
Flowers: squab (pink) red (pink = scarlet + white) ultramarine
 blue or purple; yellow for centres; black for centres
Leaves: sky blue or green and black
Ground: brown
Brushes: medium and fine

Steps:

1. With medium brush, load brush with pink, dip point in blue and paint five-petalled star-shaped flowers. With brush point to outside of petal, paint 5 petals, leaving space in centre.
2. Underneath each flower paint trumpet in 2 strokes.
3. When flower is dry, paint pink line on each flower (fine brush).
4. (Fine brush) Add yellow dots in centre of flowers, using brush tip.
5. Paint (fine brush) black dots in flower centres when yellow is dry.
6. (Fine brush) Paint small black leaves over pink trumpet sections.
7. (Med. brush) For buds, load pink tipped with blue, 3 or 4 strokes with brush laid down on paper, tip at the top.
8. (Fine brush) Black leaves from bottom of bud with flick stroke up.
9. (Med. brush) Loaded sky blue or green mixed with small amount of black, from growing point move brush-point, down, along, off immediately to make rounded end.
10. (Fine brush) Add veins in black making 2, 3 or 4 lines.
11. (Med. brush) Using black, make long flick strokes and one larger pushed stroke.
12. (Med. brush) Pale brown down strokes over base of stems. While wet add brush tips of yellow, followed by brush tips flat on paper of black from ink stone.

Composition

a) Left flower groups to be painted first, then working towards the right.
b) Note different heights of flower groups and stems are not lined up horizontally at ground level.

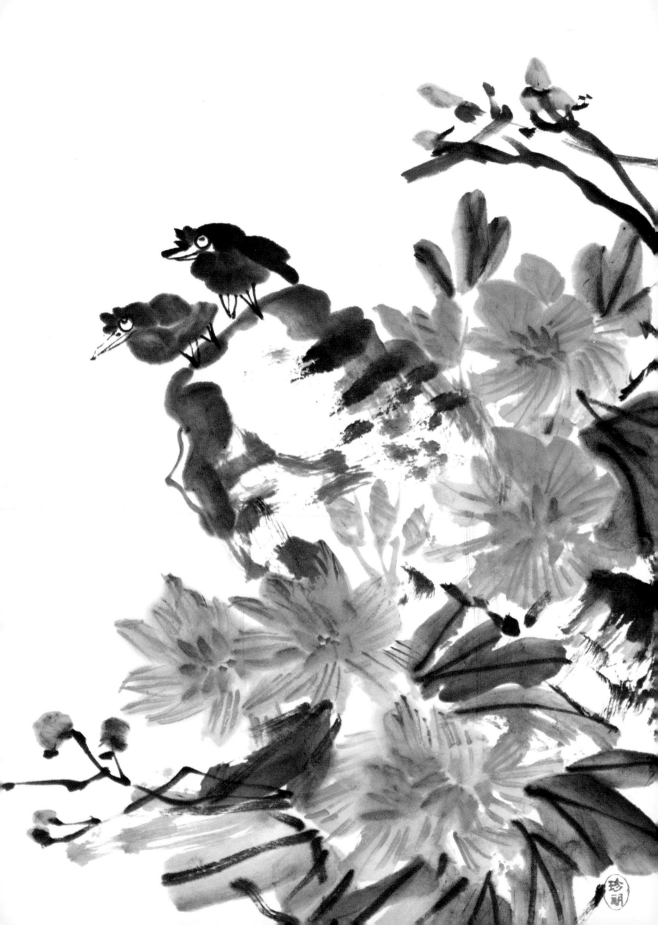

2 Colour Harmony

Azalea with birds.

Colours should be balanced so that one or two colours are stronger than the others. The dominant colour can be used sparingly, but made very striking. A subtle, light shade can be made to appear dominating by enabling it to cover a large proportion of the picture area. When talking about 'colour', several factors have to be considered. Colour consists of the pigment itself (red, yellow or blue, etc.), it embraces the concept of 'tone' (light or dark), and the saturation level (bright or dull).

Winter Jasmine is a painting which expresses some of these concepts.

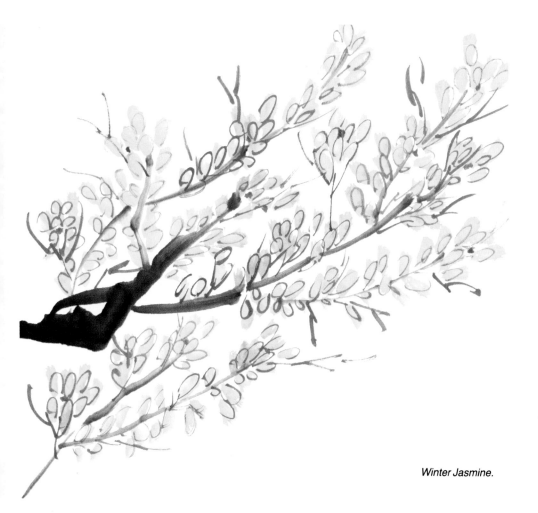

Winter Jasmine.

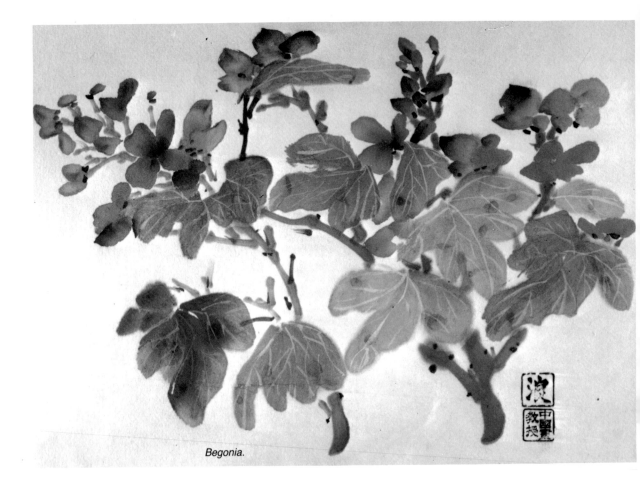

Begonia.

White is the highest possible tone, while black is the lowest. White is often added to colours, therefore, to raise their tonal value (sometimes called 'tinting'), while adding black to a colour lowers its tone (referred to as 'shading').

The large unpainted areas of white paper left exposed in Chinese paintings contribute to the tonality of the result and influence the mood of the painting. Shades of black integrated into the ink washes are also examples of tonality.

Narcissus shows how this can be so effective.

Saturation of colour is its intensity or vividness and is usually not a notable feature of Chinese painting.

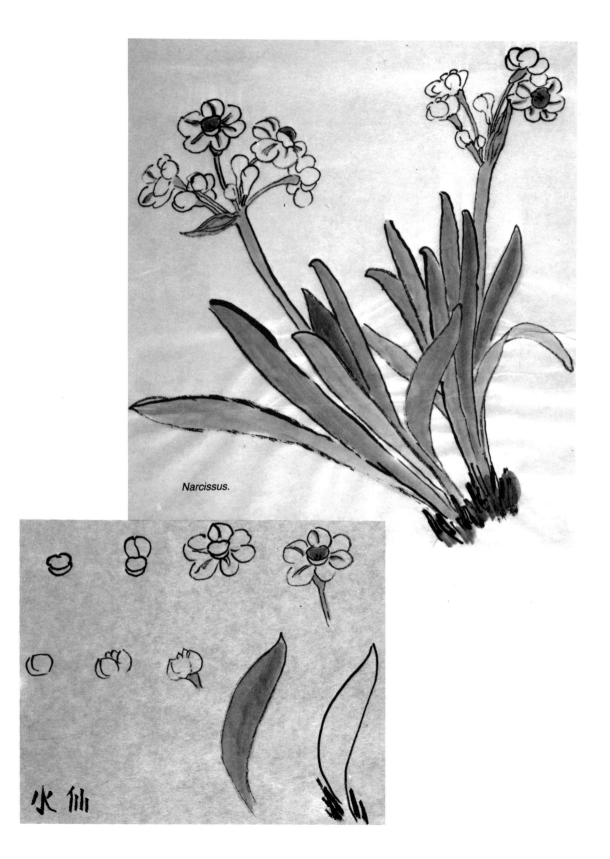

Narcissus.

水仙

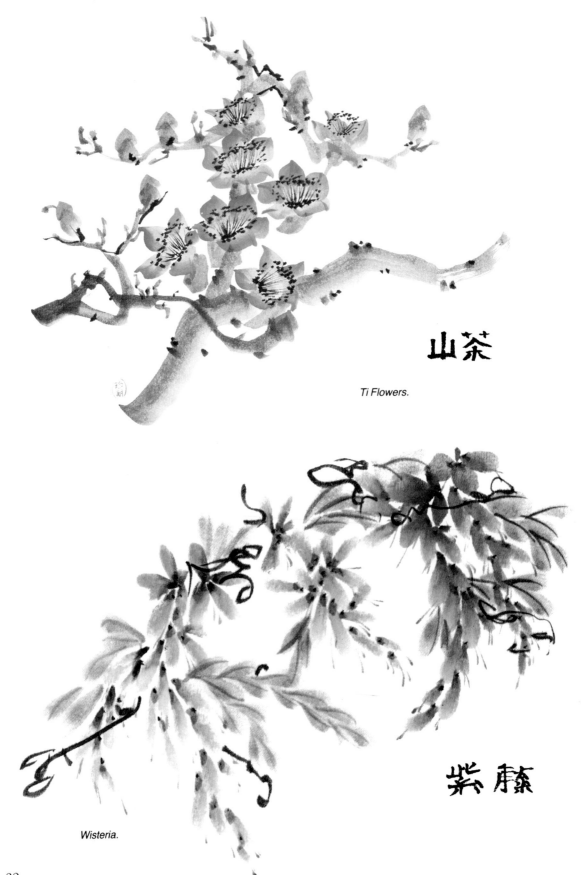

山茶

Ti Flowers.

紫藤

Wisteria.

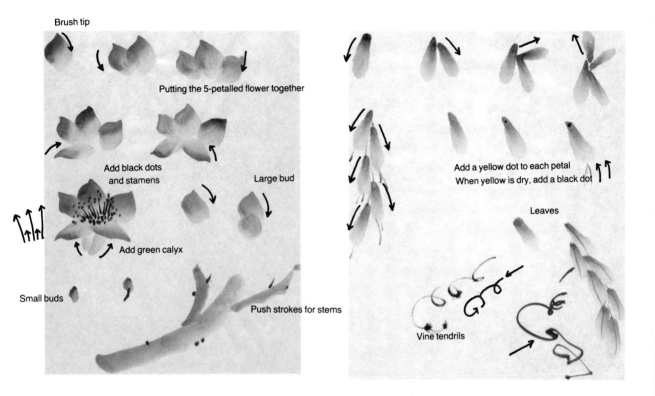

Brush tip

Putting the 5-petalled flower together

Add black dots and stamens

Large bud

Add green calyx

Small buds

Push strokes for stems

Add a yellow dot to each petal
When yellow is dry, add a black dot

Leaves

Vine tendrils

TWO-COLOUR BRUSH LOADING

Blending two colours in the brush before making the stroke is very effective. The brush should be loaded first with the main colour and then the end dipped into a different colour. For example:

Main brush loading colour	*Tip loading colour*
a) dilute gamboge	red ochre
b) indigo	black ink
c) vermilion	dark red
d) white	crimson lake

The famous Chinese flower called 'the ti flower' shows two-colour loading at its most effective.

THREE-COLOUR BRUSH LOADING

Colours in order:

a) white	b) yellow	c) red	roses
a) light green	b) dark green	c) black	leaves
a) pink	b) blue	c) purple	wisteria

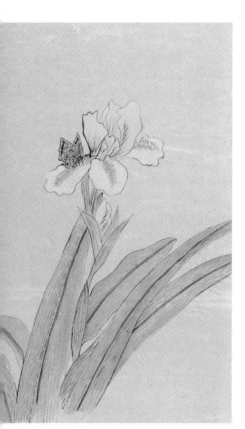

Outline Iris with butterfly painted on bamboo paper.

USE OF THE COLOUR WHITE

The Chinese advise that a little hot water can be added to the white when it is to be used, both for the painting of white flowers or when it is to be mixed with colours. A light coating of the white can also be added to the back of the painting to enhance its whiteness.

If white is to be used as infill colour, with black outlines, then especial care needs to be taken so that it does not run into the outlines. It is best to apply the white lightly and put on several coats. If the white is too thick and accidentally overlaps the outline so that it needs to be retouched, the effect of the whole picture will be spoiled. In general, white should be used with care, as it tends to darken with age.

When white flowers such as the lotus or the water lily are being painted, the tips of the petals can be touched up with white, which accentuates the form and gives strength to the stamens. Most white flower petals can be touched up in this way.

Some flowers, like the water lily and the hibiscus, have veins in their petals which can be traced in white and then colour added over the top. Stamens are often dotted in with white also.

In any paintings of flowers where the colours have been mixed with white, the colours will be enhanced by a coat of white on the back. If the colours are clear and light, then pure white should be used for the backing colour, but if the colours are dark or low key, then the backing white should be used only when tinted with the same colours.

PAINTING THE TI OR TEA FLOWER (see pp. 32, 33)

There are nearly two hundred varieties of this bush plant, some with single petals, others with double petalled flowers. They occur in a variety of colours from white to yellow, peach, pink, crimson and in this case, the brilliant cinnabar red. The leaves are dark green, thick and hard and, of course, can be used for brewing tea. Many Chinese poets have written verses to this beautiful flower.

Colours: black, yellow, vermilion, green
Brush: medium

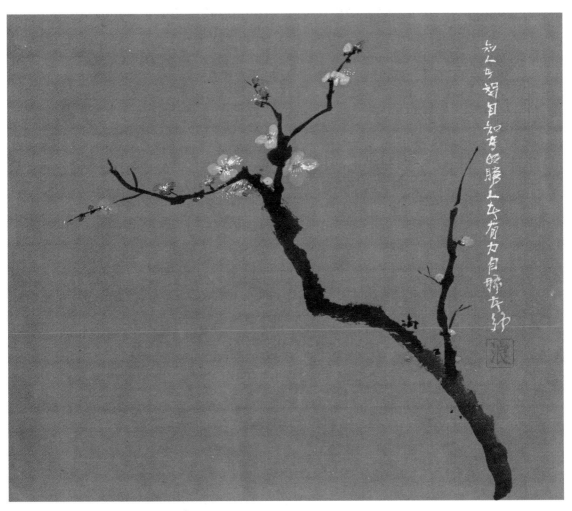

Blossom on brown rice paper showing the white stamens with a poem from the Tao Te Ching *which reads:*

'Knowing others is wisdom
Knowing the self is enlightenment
Mastering others requires force
Mastering the self needs strength'.

Steps:

1. Paint the main branches, leaving space for the flowers. The stroke used is a push stroke with the brush loaded in grey tipped with green.

2. Paint the flowers with the brush loaded with yellow tipped with vermilion.

3. Add the stamens and black pollen dots when the flower is dry.

4. Paint the green calyx under each flower.

5. Paint the large buds next.

6. Add smaller stems and twigs and join any flowers to stems using grey.

7. Add some black dots and small line emphases in black on the stems.

PAINTING WINTER JASMINE

The winter jasmine is a central and northern shrub in China, growing on slopes and precipices. It is a deciduous member of the olive family with yellow flowers blooming from February to April.

Colours: yellow, black, brown

Brushes: medium and fine

Steps:

1. (Med. brush) Paint main stems in black, leaving spaces for some flower groups.
2. (Med. brush) Paint yellow flowers. Put brush down on paper, tip towards growing point to make ⌣ shape.
3. (Fine brush) Do free thin brown lines to outline bud flowers. brown dot in group to indicate flower centre.
4. (Fine brush) Thin brown stems for hanging buds and flowerless new stems.

PAINTING THE POLYANTHUS NARCISSUS (see p. 31)

The Chinese narcissus is native to the marshy lands along the southeastern coast and is in full bloom around the end of the year. Its name from ancient days has been 'riding on the wave fairy'. It is a member of the amaryllis family with egg-shaped bulbs covered in dark brown skin. The root is white and the light green leaves are long and thick. Four to eight flowers bloom on the straight stalks.

Hibiscus – pink flowers with white vein lines.

Colours: black, yellow, green, brown.
Brushes: fine and medium
Steps:

1. With the fine brush paint the black outlines of the six-petalled flowers and buds.
2. Paint the black outlines of the leaves with the fine brush.
3. Follow this by painting the stems in black with the same brush.
4. With a medium brush add the black dots in the flower heads and the thick strokes at the base of the leaves.
5. A medium brush loaded in yellow provides the centres.
6. Mixing yellow and green on the medium brush, or brown and green, or all three, paint pale washes on the leaves and flower stems and also in the centre of the flowers.

PAINTING THE WISTERIA IN A FAN SHAPE (see p. 32)

Colours: pink, blue, purple, yellow, green, black
Brushes: medium and fine
Steps:

1. With a medium brush, paint the flowers by putting the whole brush down onto the paper, having loaded in three colours. To do this, load the brush first with pink, then scrape off two thirds, load this two thirds with blue then scrape off one third and load the tip of the bristles with purple.
2. When dry, add yellow dots with a medium brush.
3. With the medium brush add black dots on top of the yellow.
4. With the fine brush add the flowers' hanging stems in purple.
5. Using the medium brush again, paint the leaves in medium green.
6. Central leaf veins are added in dark green with the fine brush.
7. The black-loaded fine brush is needed to add the tendrils to enhance the composition. The stroke should be continuous in flow, but may leave the paper.

It is not possible to join Chinese strokes together exactly if the brush leaves the paper. It is better to leave a space. The Chinese say: 'Brush absent, spirit present.'

3 Colour Pigments and Painting Surfaces

A little colour pigment mixed with water produces a transparent solution, while adding more pigment makes the solution more opaque. The mineral pigments are deeper and richer in colour than the vegetable pigments.

A very important constituent in Chinese painting is the glue, which not only binds the pigment together, but acts as a fixative for the colour as it dries. Colours or inks, therefore, can be painted on top of each other without causing any running or bleeding. The fixative also helps to bond the pigment into the paper so that it does not run when washes are added or paste is used for the mounting process. When raw silk is used as the painting surface, the pigment sinks into the surface, diluting the colour and impairing the quality of the line. To deal with this problem, silk used to be treated with size, which made the material less absorbent, but the only way to paint on it was to use slow, careful movements, resulting in rather formal compositions. Spontaneous brushwork is at its most effective on absorbent paper which sucks the pigment from the brush. Chinese paper, with its long fibres, does not disintegrate when wet, but the amount of water taken in is difficult to manage. Papers, therefore, are sized to produce different degrees of absorbency. Sizing makes the paper smoother and the surface slightly water-resistant.

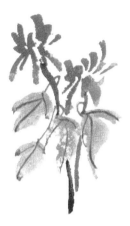

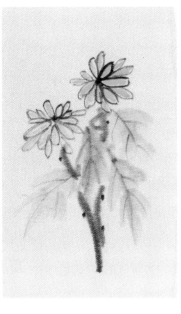

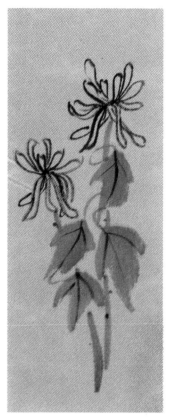

Small flower paintings illustrate a variety of fabric surfaces.
1. *Raw silk (the pigment sits on the surface).*
2. *Smooth satin (fairly absorbent and similar to paper).*
3. *Woven polyester satin (fairly absorbent, but lines are difficult to paint as the surface grain deflects the brush).*
4. *Smooth nylon ribbon (non-absorbent, so the pigment can only be used thickly and painted slowly).*

The texture of silk is regular and porous as created by the warp and weft. Sized paper has a tighter texture and, although it seems smooth, there are subtle variations produced by its base vegetable-type content and the way in which it was dried. Brush strokes themselves have a texture according to the amount of liquid in the brush. The combination of dry and wet brush strokes on different qualities of sized papers produces a variety of textural effects. Sometimes individual brush movements leave their traces on the paper, other times the brush is wiped across

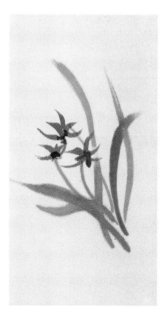

The results of adding water to the pigment.
Dark green (1) has been used as the base pigment. The first four leaf strokes have had progressively more water added, while the horizontal fifth stroke is a result of adding white pigment to the green. The first four shades demonstrate how the pigment becomes more and more transparent, although the weaker, wetter colour is much more difficult to handle. However, it is not an acceptable alternative to add white, which produces a paler, but non-transparent colour.

The two red pigments are: (6) cinnebar red, which is a vegetable colour, and (7) bloddy red, which is a mineral colour. The mineral bloddy red is deeper and richer than the vegetable cinnebar.

A vertical dry brush stroke and a leaf stroke on four different papers
1. Ordinary white rice paper (great absorbency).
2. Bamboo paper (slightly brown in colour; smooth but not very absorbent).
3. A white coarse-fibred paper (absorbent, but the brush flow is interrupted by the fibres).
4. A lightly dyed paper with positive vertical grain (medium absorbency).

the surface, magnifying the effect on paper with a minimally-sized surface.

Most painting surfaces have a smooth and a rough side which can be gauged by touch. Painting is usually carried out on the smooth side unless a special effect is required. Care should always be taken not to drag the brush with too much pressure over the painting surface, particularly in the case of paper, as this may scrape the surface off.

PAINTING SURFACES

The painting surface is vitally important for Chinese techniques as it influences the style which may be used for the best results. Whether the surface is rough or smooth, dull or glossy, or more or less absorbent, considerably affects the way in which the ink or colour leaves the brush to combine with the surface. Basically there are two different styles of painting; the careful and the more spontaneous free-style.

Vertical brush position.

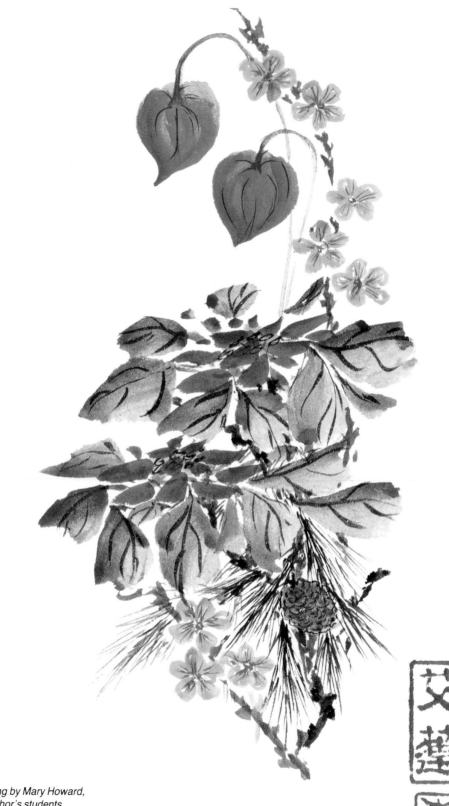

Flower painting by Mary Howard,
one of the author's students.

The carefull style reflects the more academic type of painting and is called *kung pi* which means 'industrious' or 'labouring' brush. In essence it is almost like drawing. The brush, which is held vertically with only the tip touching the surface, is used to produce lines. *Kung pi* requires a less absorbent surface to keep the lines clean and clear, so sized paper or sized silk is the easiest surface on which to paint.

The free, spontaneous style, which can produce 'flying white' or 'splashed ink' paintings, uses the brush in a slanting manner, where absorbency is the key to the exuberant results. The brush needs to open out on the paper, so unsized papers or rough silks with the same characteristics are required for the surface material on which to paint. This style is the style of the non-academic painters, the monks and scholars of the Southern School of painters who prefer to paint solely in shades of black.

In the spontaneous style, overpainting does not usually occur, so each brush stroke is of vital importance, while paintings in the careful style, where colour is added mainly as a fill-in, can have some controlled line additions made if necessary.

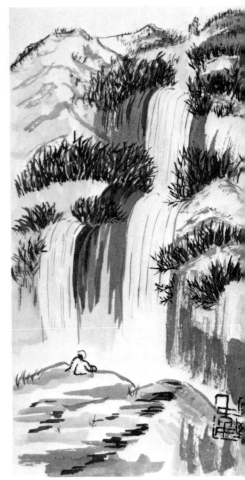

Landscape painting by Doug Wells, one of the author's students.

The point of the brush leads the stroke direction.

43

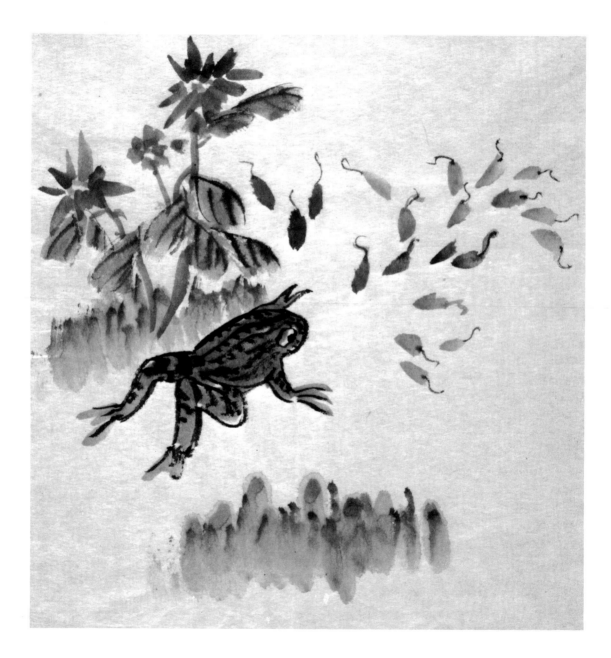

Paper

Many of the various types of paper bear poetic names, such as the Sung paper called 'Paper from the Pure Heart Hall', bamboo pulp paper called *hsüan chih*, which is white and fine and still in use either sized or unsized, old treasure house roll called *chiu k'u p'i* and the mirror-smooth paper called *ching mien kuang*. In the main these can be divided into two categories: the more absorbent, unsized papers and the less absorbent sized ones.

Unsized papers, being most suitable for the spontaneous type of brushwork, are usually dominated by free ink strokes which run easily on the paper, so good control is essential, particularly as each kind of paper has a different degree of absorbency. All unsized papers dry slowly, as the surface is quite rough. Ink and light colours only are accomplished best on these papers and although the brush strokes are quickly completed individually, the painting can take quite a long time to finish because of the paper's slow drying qualities.

Nowadays, sized papers can be purchased ready for painting, although some artists still prepare their own. Animal or fish-bone glue is mixed with size made of alum and then painted on to the paper so that it is thoroughly soaked. The side on which the mixture has been applied is smoother than the other side and is usually the one used for painting.

In addition to the actual effect of the glue and size, the fact that this paper has already been thoroughly wetted means that some of the absorbent qualities have been already used up, so that the ink or colour will not run so quickly and the sized paper will dry much more quickly than the unsized paper.

Of course, the very experienced painter is capable of producing either free or linear strokes on both sized and unsized paper, but, in general, using the most appropriate surface produces the best results.

Frog and flowers painted on Japanese Ganpishi *paper. Notice that the flower leaves have broken edges and the strokes for the water plants allow both water run and pigment collection.*

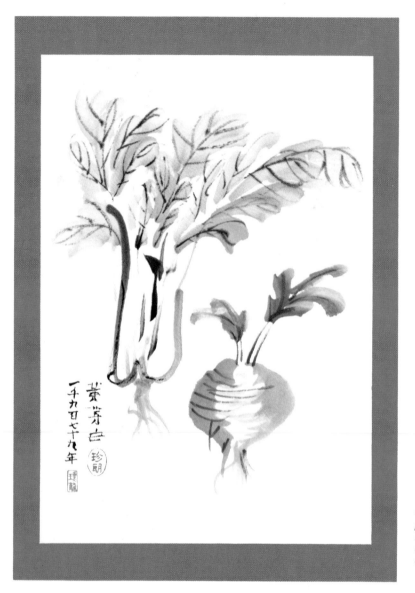

Chinese vegetables are a very popular subject for Chinese paintings and in particular the Chinese cabbage (or as it is sometimes called, Chinese leaves).

Silk

As a painting surface, it is necessary to size silk before it can be used at all, otherwise the paint has no adhesion and runs right through the material. The closeness of the weave also affects its qualities as a painting surface, but, in general, its characteristic behaviour when used for Chinese painting is somewhere between sized and unsized paper.

Because the silk is sized it dries quickly and gives sharply defined strokes when the amount of liquid in the brush is care-

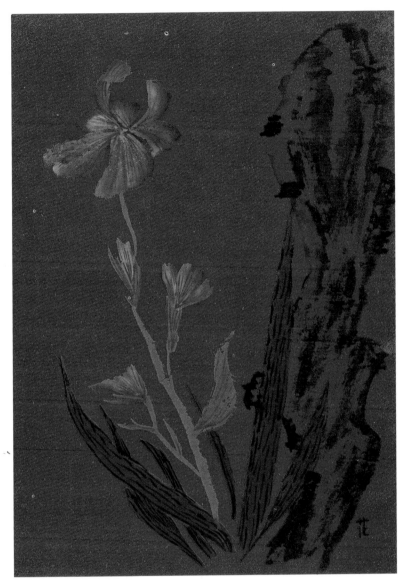

Iris and rock painted by the author on coloured rice paper. It is possible, although difficult, to obtain dyed Chinese paper, but due to the dye having used up most of the paper's absorbent qualities, the surface reacts to the brush in a non-absorbent manner.

fully controlled. However, because of the material's weave, the surface is not as smooth as sized paper, so that it also takes the free brush relatively well.

Most Chinese artists tend to use silk more for colour-based paintings than for those where black is the dominant medium. Moreover, because silk does not need to be back mounted, the colours used are often stronger than if paper was the painting surface. Examples of the same composition painted on different surfaces demonstrate the important part that paper and silk

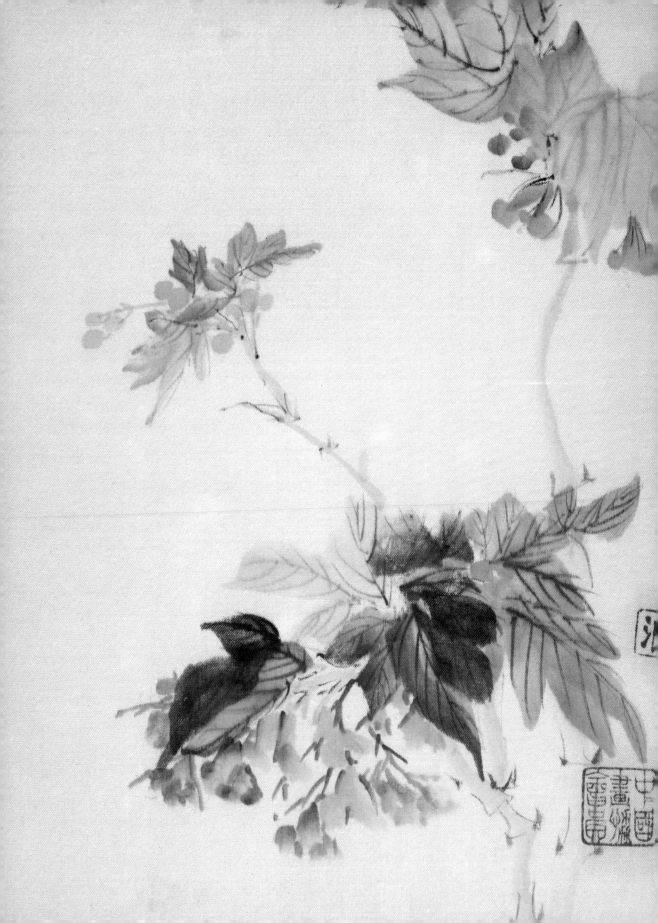

Begonia. Notice the texture of the vein lines on the leaves which have been affected by the grain of the silk when the strokes are painted in different directions.

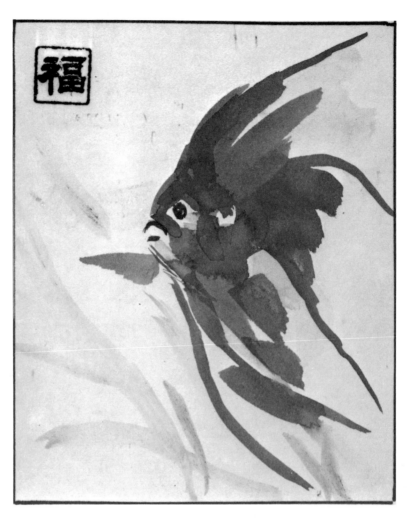

This angel fish by Mabel Daniels has been painted on a type of card. The pigment tends to 'sit' on the surface when the painting surface has little or no absorbency.

play in conveying style and mood in Chinese paintings.

In *The Way of the Brush*, Van Briessen describes Chinese painting as 'endless philosophising with a brush, an instinctive worship of one of the central ideas of the Chinese mind – that of Yin and Yang, the opposites which are complementary, the interplay of masculine and feminine'.

YANG (masculine)	YIN (feminine)
brush	paper
using the brush	using the ink
sized paper (hard)	unsized paper (soft)
sized paper	easier brushwork
strong brushwork	unsized paper

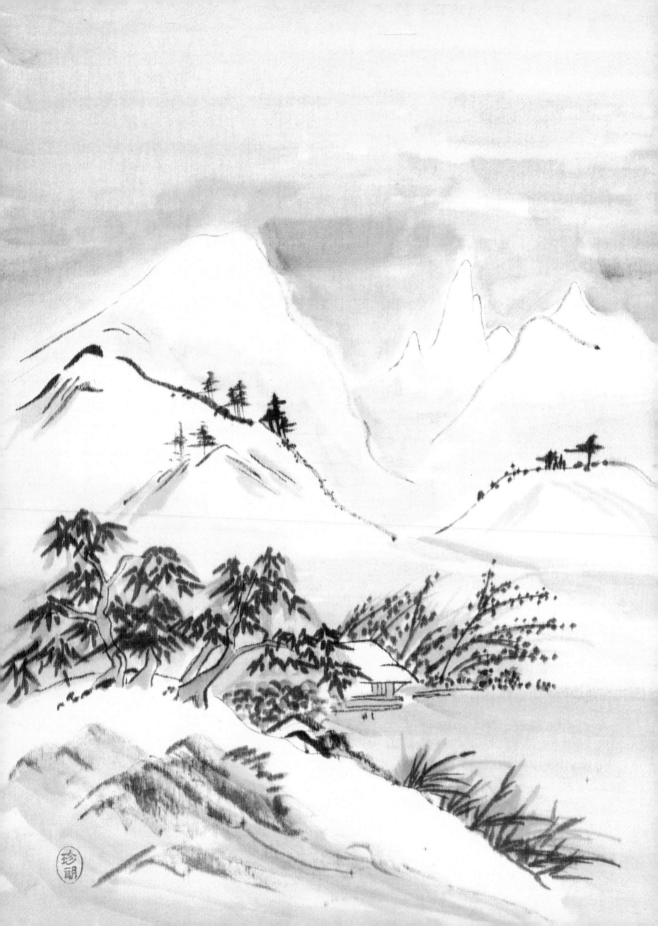

4· Colour Washes

A wash is achieved when the pigment is spread in large areas over the surface of the paper so that the individual brush strokes are not generally apparent. Large, soft brushes are needed for big areas of wash, with the brush held at an angle to allow more bristles to sweep across the surface area.

There are five possible methods of applying a wash to a Chinese painting.

1. After painting in the ink contours first, the colour wash should be added inside the lines. This is used mainly with the outline flower technique.

 Mix the colour with water in a saucer and use the brush to stir together. To obtain the right shade, add either more water or more colour. If large amounts of this type of wash are needed, all exactly the same shade, then ensure that a sufficient quantity is prepared. However, it is often better to mix small amounts for flower painting so that each flower is a slightly different colour and the picture becomes more varied.

2. For larger areas, such as water or sky, the wash is again applied after all the black ink-painting is finished, but this time the paper can first be wet with clean water (the excess moisture being removed by dabbing with another piece of absorbent paper) and then the colour applied. It occasionally helps to have another *clean* brush ready to smooth in the painting strokes, which should all have been applied in the same direction.

 It is not essential to wet the paper first before applying the wash. The slightly 'cockled' effect as the paper dries will disappear if the completed dry painting is flattened under a weight such as a heavy book.

 If traces of the brush show when painting water, it is called *tzu* (saturating) while the light ink and dry brush wash used for waterfalls is called *fen* (dividing).

 It is quite permissable to apply several layers of wash, each time waiting until the previous wash is thoroughly dry. Very interesting colour effects can be obtained using this method.

Snowy Landscape. As areas of the painting have to be left blank to indicate the snow, this silk painting has had to have its areas of wash applied very carefully.

Poppies. The flowers' petals have been infilled with small areas of wash.

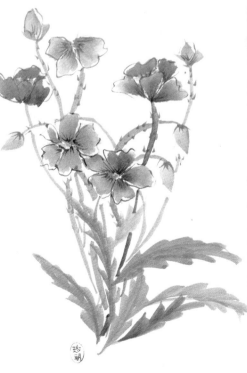

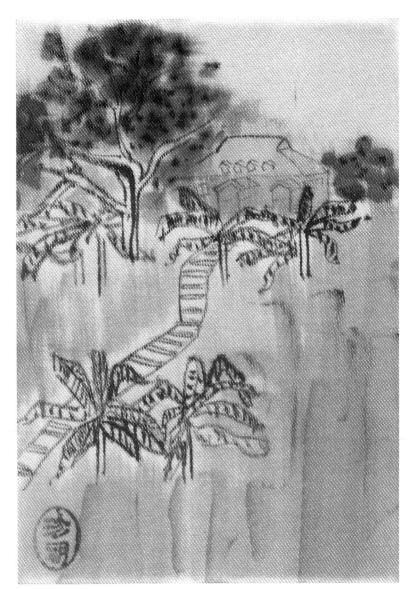

Village Palms. A small silk landscape with a pink all-over wash.

Fu Baoishi (1904–1965) used to accomplish his translucent washes by painting them with a dry brush on wet paper in his studio. Sitting by the fire, drinking wine, he found that the heat of the fire dried the paper very quickly, making the wash paler than usual.

Three or four layers of light ink washes are called *hsuan* – meaning wash. Soaking the whole painting is called *hua* meaning cleansing.

3. Another technique which can be employed to obtain a smooth all-over wash is to apply the colour to the reverse of

A Chinese Landscape. This painting was given an all-over wash with tea to produce a fine even antique tone.

the painting. Most Chinese paper has a smooth side and a rough side. It is usual to paint on the smooth side of the paper, so that the brush strokes will flow more easily over the surface. However, for an overall one-colour wash, normally applied in a pale tone after the main body of the painting is finished, the paint may be applied either on the right side or the 'wrong' side of the paper.

4. To create an impression of antiquity, some painters use tea as the wash medium. Testing on small samples of the painting surface first, to see what strength of 'brew' is required, a

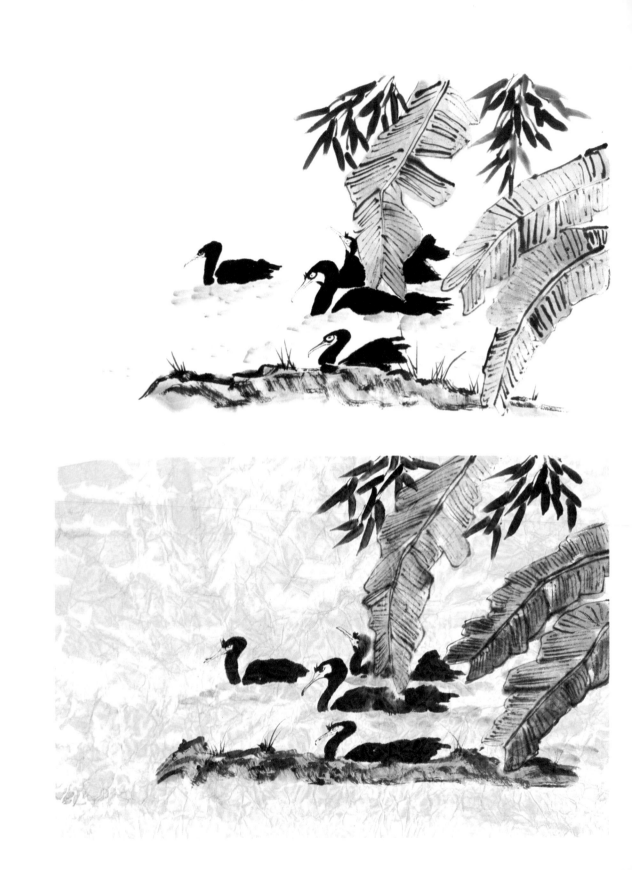

suitable colour can be applied to any painting, whether on silk or paper. It is most effective when used on white paper, and landscapes benefit greatly from this type of wash.

5. Crackle wash is a rather unusual modern type of applied background, to be used on paper only. It developed from the ancient technique of Batik. When the compositional element of the painting is completely finished and thoroughly dry, the area to be crackled is crumpled up in the hand and pressed firmly so that creases appear. In the first instance this should be tried experimentally with a whole small painting and definitely not with 'a masterpiece'. Then open out the painting so that it is reasonably flat, but do not press too hard as it is vital to retain the creases as raised areas. The wash is then applied with a not too saturated brush, loading the brush so that it is not as wet as it would be for a normal wash. The brush should pass gently over the paper with little pressure. The raised sections will absorb the water, leaving the hollows or cracks untouched. A random pattern of colour and untouched paper will result which very effectively represents water or undelineated green foliage. Light colours, blues and greens, are most suitable for crackle wash.

WASH – POSSIBLE FAULTS AND SOLUTIONS

Fault

a) The original painted colours, under the wash, run.

 (i) *Reason* The original colours were put on too thickly.
 To avoid this Use less pigment in the original painting.

OR

 (ii) *Reason* The basic painting was not dry when the wash was applied.
 To avoid this Allow the basic composition to dry thoroughly before applying the wash.

b) Uneven patches appear in the wash.

 (i) *Reason* Not enough paint was mixed for the wash and more had to be made quickly.
 To avoid this Mix more wash than you think will be sufficient. The paper absorbs a great deal.

OR

 (ii) *Reason* The wash brush was applied in different directions.
 To avoid this Apply the wash horizontally from left to right.

Black Swans. Two versions of the same painting, demonstrating the effect of a crackle wash.

55

OR

 (iii) *Reason* The wash dried too rapidly.

 To avoid this Allow the painting to dry slowly, laid flat on an absorbent surface such as newspaper or blotting paper.

OR

 (iv) *Reason* The brush strokes overlapped when the wash was applied.

 To avoid this Apply all the large, soft hairs of the brush to the paper in regular strokes.

c) White spaces appear where they were not intended to be.

 (i) *Reason* The brush strokes were not applied evenly.

 To avoid this Apply the wash brush to the paper in regular strokes.

 Depending upon the composition, it may give an added dimension to the painting if some areas are of stronger colour due to two layers of pigment overlapping, or it may be beneficial to the painting if streaks of the white base paper are allowed to show.

d) The painting paper tears.

 (i) *Reason* Too much brush pressure has been applied.

 To avoid this Let the brush glide smoothly over the paper without pressing too hard.

e) Scraped surface – bits of the paper collect in small lumps.

 (i) *Reason* Too much pressure has been applied to the paper surface.

 To avoid this Be much gentler with the wash brush and ensure that the brush is not too dry.

f) Blotches of paint appear in the wash.

 (i) *Reason* The material underneath the painting paper is not absorbent enough and liquid goes through the Chinese paper and is then pushed back into the painting.

 To avoid this Use more absorbent material underneath the painting.

OR

 (ii) *Reason* The brush did not move continuously across the paper, but paused *en route*.

 To avoid this Make the even brush movements essential for a smooth wash.

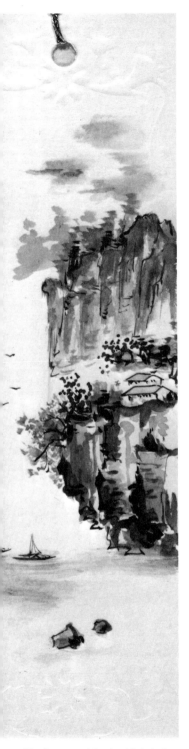

5 The Elements of Chinese Composition

Even when painting a natural scene, the artist involves himself or herself in both conscious and unconscious choices. In Chinese painting in particular, where the choice of painting subject evolves from the mind and not by sitting, sketch book in hand, looking at a flower, animal, insect or scene, the artist's own memory, mood or predeliction forms the general composition before brush touches paper. Composition is a crucial element in this conceptual form of art, which is also endeavouring to convey a philosophy of nature through painting. Chinese painting is a studio art. The painter sits alone reflecting on his memories, shaping the natural external world to fit his own emotional concepts. The principles of Chinese composition are based upon the ebb and flow of opposite strands which relate to each other, like gossamer threads, woven across the painting in a complicated intertwining pattern. The Chinese call these 'connections' dragon veins (*lung mo*). It is simplest to understand when watching an artist paint. The addition of a small dot, another branch, a boat in the distance, can suddenly make the painting come alive, as though the overall balance of the composition has suddenly been completed.

The Host-Guest principle (*pin chu*), where an element of the composition is set in a paired relationship representing the passive and aggressive, is common to most Chinese paintings. The best examples are shown in three groupings, where two trees stand side by side, one bending or enfolding the other. Usually the trees are contrasting in types or, alternatively, one is thin and straight, while the other is of different height and width. Parallel lines and clumsy curves are avoided. Sometimes the pair is described as 'taking each other's hands' as branches intertwine in friendly proximity. The principle is then expanded in the composition to include another group of trees which bear a Host-Guest relationship to the first pair.

Compositions include not just trees, but mountains, rocks and people, related in this way. Moreover, it is not sufficient merely for parts of a composition to be related, it is also necessary for the entire painting to be combined to form a cohesive whole.

The boats and the tiny birds help balance the composition in this landscape.

This extension of the Host-Guest principle is called 'Opening and Closing' (*k'ai ho*). Where short threads hold the small elements together, long threads hold the entire picture together.

Some elements open up the picture, opposing elements give it stability, completing a painting by turning towards each other, while at the same time forming a contrast. These pictures illustrate some of the different ways in which this principle is applied. Of course, the focus of a painting never occurs in the middle of the painting area, otherwise the composition would appear totally static.

Chinese artists place great emphasis on capturing the illusion of nature in an impressionistic manner. Paintings cannot be truly abstract, but have to have recognisable subject matter. This was laid down as one of the six important rules of Chinese painting by Hsieh Ho in the fifth century AD.

The dictionary defines perspective as 'the art of drawing objects on a surface so as to give the effect of distance, solidity etc.' It is the way in which a painter can make it appear that the viewer looks through nearer distance towards things in the far distance. The Chinese painter employs two general techniques to achieve this. Linear perspective, which involves proportion and placing; and atmospheric perspective, which depends upon the use of clear tone and colour.

'Up' is the far distance in landscape paintings, usually arranged on a diagonal, often following the meanderings of a river.

Another method used to denote far and near is demonstrated by dividing the landscape into three distinct sections to represent near, middle and far distance. This is an artistic multiple vision not in any way realistic, as the eye could not possibly take in at one look all the elements of the panorama spread out to the view.

Atmospheric perspective, where far distant areas are paler in colour and tone, is generally demonstrated by mountains shrouded in mist or rocks and trees with unclear lines. Voids, the unmarked area of paper which the brush has not touched, also serve to render by means of the blank space the size and distance of a landscape painting.

Ancient Chinese beliefs about the relationship of Heaven to Earth are also reflected in the painting composition. This principle (*t'ien ti*) concerns the disposition of the upper and lower

Trees, taking each others' hands.

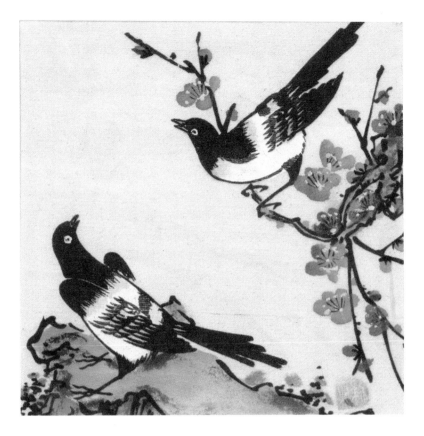

One pair of opening and closing elements.

areas so that they relate to each other in harmony, thus achieving a vertical balance.

At the moment when the first brush stroke touches the paper, all these compositional elements have been considered, perhaps not consciously, but because years of practice have infiltrated the mind's consciousness. It is the Chinese aspects of composition which prove most difficult to the Westerner attempting traditional painting. To emulate the Chinese painters, it is necessary to work through the same disciplines of practice and copying from the Masters which they undertook, which will, in time, produce an instinctive knowledge of how a composition should be formed.

The painting builds itself up from the first brush stroke; a single leaf becomes a group, a tree becomes a forest, then all combine to produce a pleasing entity.

The principles of Host and Guest, Opening and Closing, Heaven and Earth are evident at each stage of the painting, continuously developing towards the final result.

Three examples of paintings with two or more pairs of opening-closing elements in each.

A landscape with three distinct sections to give perspective.

Voids of space to give atmosphere are elements of this landscape.

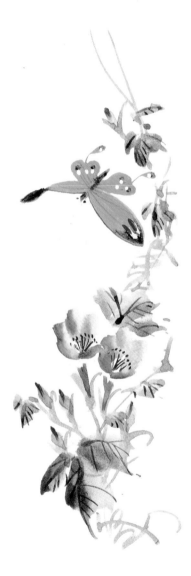

The harmony of vertical balance.

This flower and butterfly painting embodies all the previous principles flowing together to make a cohesive entity.

63

6 Chinese Gardens

A Chinese garden represents the symbolic essence of nature. Here the painter can sit or stroll, watching and absorbing the 'nature of nature'. Such gardens are not filled with a plethora of flowers and shrubs, or distinguished by vistas of grassy swards. They are not formal, symmetrical arrangements, but carefully conceived areas of nature in harmony, replicating in miniature the vastness of the universal landscape. Poetry, calligraphy, landscape painting and gardening are interwoven arts, not all to be taken in at once, but to be discovered bit by bit from everchanging viewpoints. Plants are not the most important elements of a Chinese garden: it combines rocks, water, trees, white walls and pavilions in such a way that small spaces expand mysteriously as the seasons change. Courtyards, like space-cells, merge from one to another, leading the visitor into small havens of different experiences. From different viewpoints the enclosed privacy expands as branches move in the wind against the white lattice walls, leading the eye into a distance, hazily seen through a decorative archway.

Nature in Harmony.

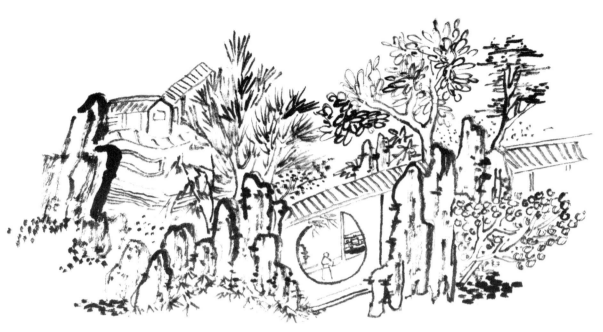

The Chinese Garden.

The Chinese garden is a celebration of change. Peonies grown together in one garden area might be the focus in early summer when visitors would arrive to honour them by party-like enjoyment, sitting sipping wine, writing poetry and enjoying the view. As the summer heat increased the garden guests would move to a cooler area, possibly an open pavilion (called a *t'ing*) set near the water, where water lilies could be admired in their natural setting.

Autumn was a time to appreciate chrysanthemums or orchids. Houses without gardens would make their gardens in pots. Large bowls filled with lotus might stand in the courtyard or either side of the main entrance, to be changed for chrysanthemums as the season moved on. Herbaceous plants, dwarf trees and miniature landscapes were also possible for those without much space. Even fish could swim lazily in the large open-mouthed Chinese jars made specially for the purpose. Indeed, fish were bred specifically to be seen and appreciated from above.

The essence of a Chinese garden may lie more in the calm, everchanging delights which appear throughout the seasons, than in the actual flowers and trees themselves.

Owners gave their gardens evocative names such as Dreamy Tower, the Place of Clear Meditation, the Bower of Nature, or they referred specifically to special garden features – the Plum Slope, the Lotus Cove, the Peach Tree Banks. The Chinese poet Yuan Mei in the 1750s, was said to have had a garden with

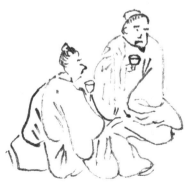

Sipping wine in the garden (from The Mustard Seed Garden).

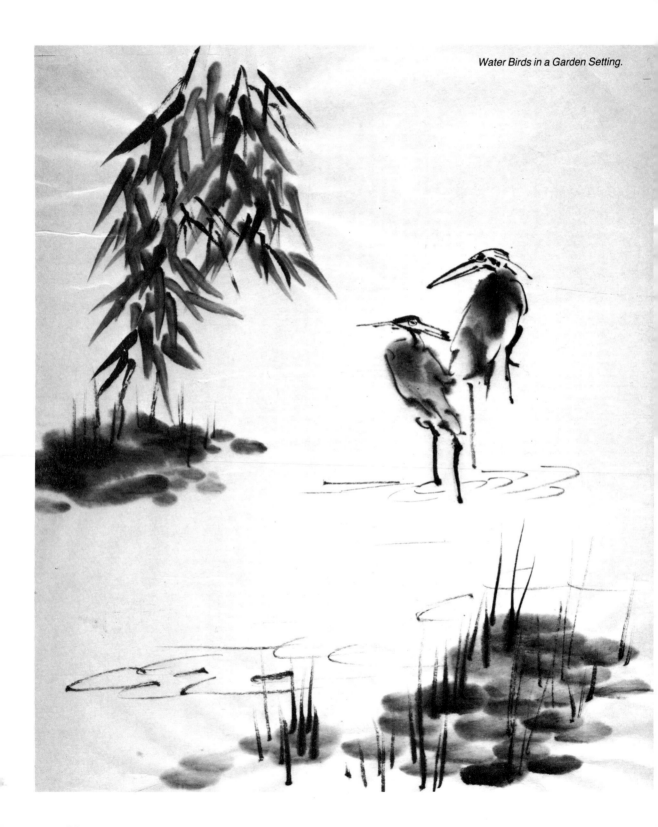

Water Birds in a Garden Setting.

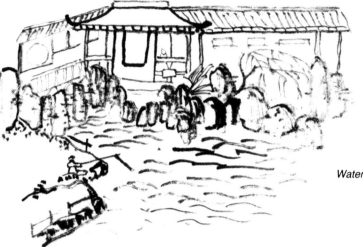

Waterside Garden.

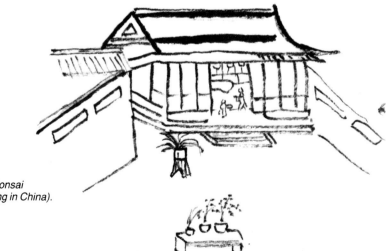

Miniature plants (now called Bonsai by the Japanese, but originating in China).

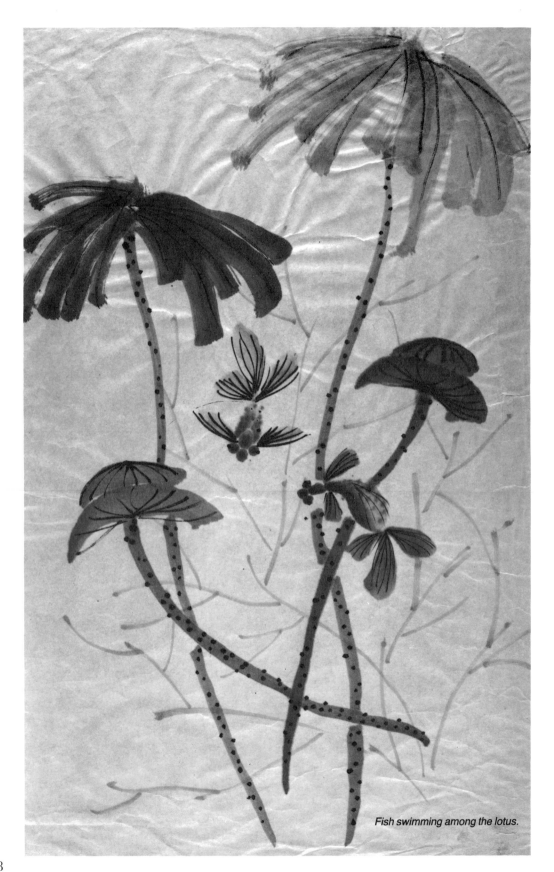

Fish swimming among the lotus.

twenty-four separate named pavilions. '*Cho Cheng Yuan*', a garden in Soochow, means 'Garden of the Unsuccessful Politician'.

A very ancient game, celebrated in many paintings and poems was exemplified by the eighteenth century Peking 'Pavilion of the Floating Cups'. The pavilion, standing over a stream in the garden, was used by guests, who had to compose a poem in the time it took a wine-cup to float down the channel of water from one end to the other. Failure meant drinking the wine and trying again. Many famous poems were written in these circumstances!

Characteristic features of a Chinese garden were the varied rocks, which represented the mountainous elements of the landscape, transferred to the smaller scale of the garden. Large standing stones, flaring out from narrow bases, hollowed by weather and time and riddled with holes, symbolised the Tao and the mountains. These stones were brought at great expense from distant areas to grace the Chinese garden. Although they are almost like sculptures, they had to be naturally formed.

Mi Fei (twelfth century) was not only a painter, poet and calligrapher, but was also noted for his love of these big stones. It is said that he bowed every day to the giant rock in his garden and called it 'elder brother'.

Horizontal Garden Landscape (painted on silk).

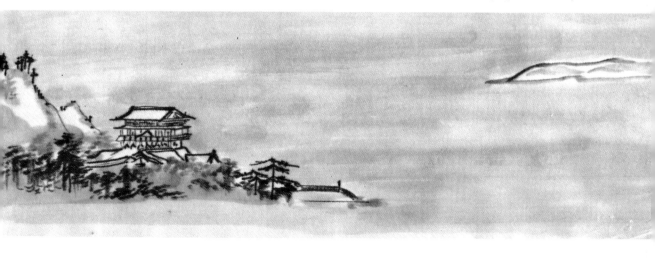

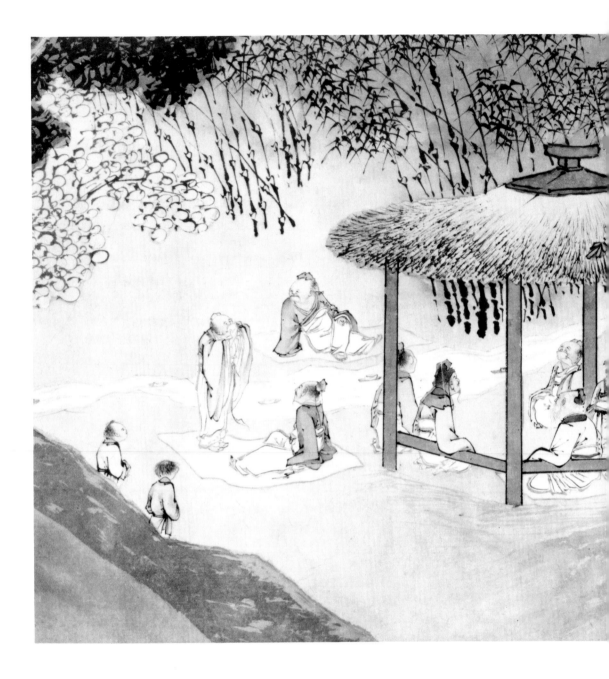

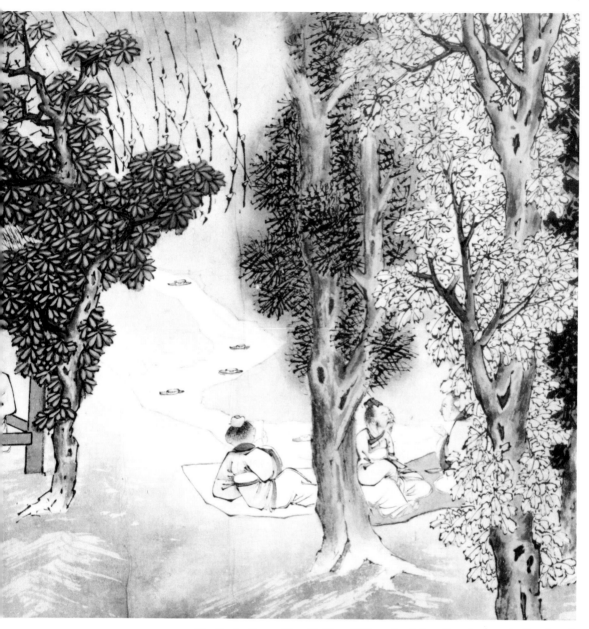

The Poetry Competition. Gu Yuan (19th century). A section of unmounted handscroll 31.3 × 480cm. Ink and colours on paper. People are sitting in the tsin *watching the competitors write their poetry.*

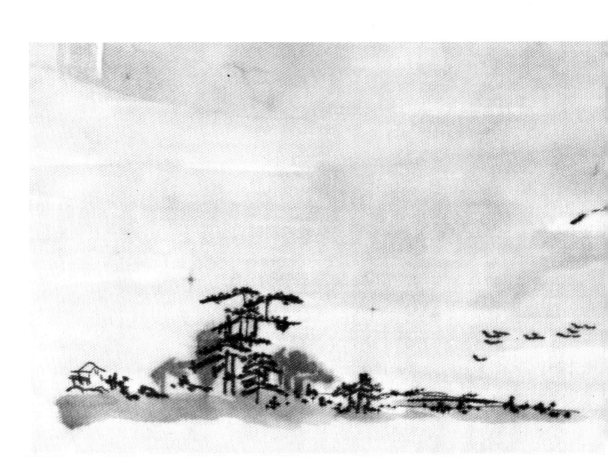

The essence of landscape: simplicity with space as its most important feature (painted on silk).

A large decorative stone.

Wu wei, meaning 'no action' or 'no action contrary to nature', formed the basis of intuitive garden design: places where man can harmonise with the flow of nature. The Taoist attitude to life is of inner solitude, whereas Buddhists join together to enjoy the quiet peace of the garden, thus Buddhism changed the concept of the Chinese garden from a solitary place to an area for more general enjoyment.

Sitting on a rock watching the water (from The Mustard Seed Garden*).*

Landscape. Wang Wei (699–759). 28 × 37cm. Ink and colours on silk. The pine and the rocks are very finely drawn.

The T'ang poets added a new concept to the garden – poetry carved on stone came to be regarded as an essential aspect for the enjoyment of this Chinese microcosm of life.

Two kinds of writing are found in gardens in addition to the formally inscribed couplets. There are also poems written by visitors to commemorate their enjoyment of the garden or the gatherings of friends; and the third category are the poetic names given to the different aspects of the garden, like the 'Centipede Bridge.'' Later, stone walls and little bridges added shades of white and grey to the green domination of the garden.

Wang Wei (AD 699–761) the great poet-painter is credited with the invention of the long handscroll, which, as it unrolls from right to left, connects the painted spaces by water and

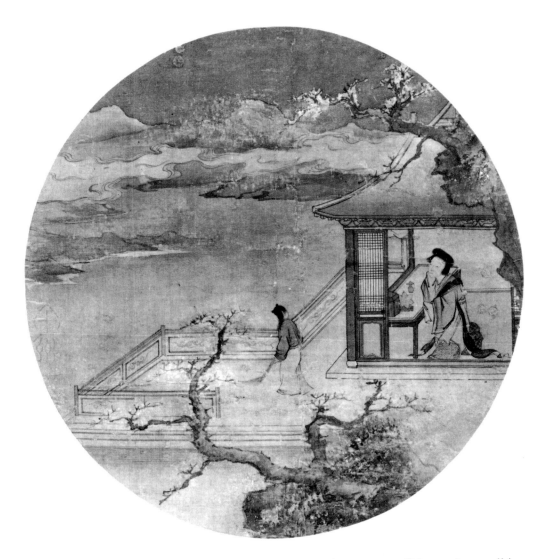

Lady meditating by a lake.
Ch'in Ying. 7 + 3/8 in. circle.

mist. The landscape or garden scenes roll by as the scroll is unwound, so that movement is generated from the static painting. In the same way, the small space-cells of a Chinese garden, divided by white walls representing mist, replicate the three-dimensional walk through a landscape scroll.

Ch'iu Ying (1510–1551) was a famous painter of gardens who emphasised the contrast between the 'wide-open' and the 'screened' aspects of the Chinese gardens. Balustrades can have 'cracked-ice' patterns, pathways meander like playing cats, the water is a place where 'the moon washes its soul', while even buildings are constructed in shapes such as fans, plum blossoms or butterflies.

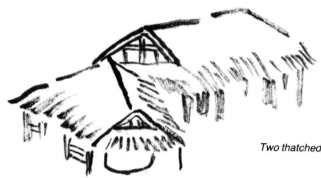

Two thatched huts (from The Mustard Seed Garden*).*

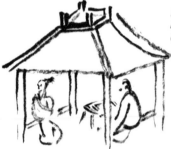

*Example of a square pavilion which can be seen
in the shade of trees, where strollers may stop and rest
(from* The Mustard Seed Garden*).*

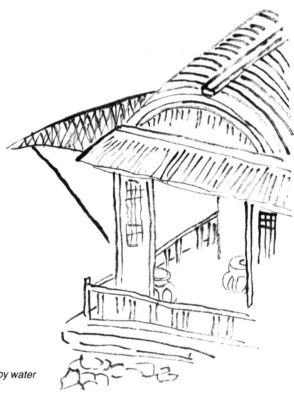

*A high balcony surrounded on three sides by water
(from* The Mustard Seed Garden*).*

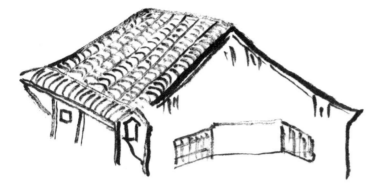

A secluded pavilion for study; the shades and windows on all four sides may be opened to the view (from The Mustard Seed Garden*).*

The most popular of the small garden pavilions, so essential to a Chinese garden is the *t'ing*. It is an open-sided viewing building, providing personal shade or shelter from the rain. Like man, it is a tiny but essential part of the landscape. Other types of buildings in gardens are the *hsieh*, which is an open pavilion, like a porch, for resting on a walk; the *chai*, which is a form of small studio; and the *fang*, described as a 'boat with no mooring', is a pavilion that stands in the middle of a lake.

Larger buildings featuring in more grandiose gardens are the multi-storied *lou* or *ko*, while the centrally situated buildings are called *t'ang*.

The Chinese garden is a never-ending source of pleasure, not only throughout the seasons, but in the evenings as well as the daytime.Its atmosphere of calm tranquillity encourages the artist to absorb the essential essence of the individual flower and tree and thus inspires works of art, both written and painted, which are imbued with symbolism and a feeling of the inspirational quietude of nature.

FLOWERS FROM CHINA

Many flowers, fruit and shrubs currently grown in England originated in China. Some were brought by plant collectors such as William Kerr, whose expedition of 1805 resulted in the importation of *Kerria japonica*, *Pittosporum*, *Rosa banksiae*, Tiger Lily, *Lonicera japonica* and *Pieris japonica*. Others arrived via other countries such as Japan, India or North America. In 1879, Charles Maries imported *Primula obconica*, witch hazel (*Hamamelis mollis*) and *Loropetalum chinensis*.

The following list is not exhaustive, but indicates how much our gardens owe to a Chinese inheritance. Dates are given for the year of introduction where it is known; some plants have their botanical names, others their more common names.

Ailanthus altissima (tree of heaven), 1751
Althaea rosea (hollyhock)
Anemone japonica, 1844
Buddleia davidii, 1896
Camellia and Theaceae (tea plant grown in the UK in 1739), c. 1700 (see p. 33)
Chimonanthus praecox
Chrysanthemum indicum, c. 1793 (300 varieties of chrysanthemum listed in China in 1708.) (see p. 39)
Citrus (oranges and pomelos were mentioned in relation to an Emperor of 2000 BC), c. 1700
Clematis
Clerondendrum
Cotoneaster, 1879
Cymbidium orchid (see p. 39)
Daphne (lilac)
Davidia (dove tree)
Deutzia
Edgeworthia (paper bush)
Eriobotrya japonica (loquat) (see front cover)
Exochorda
Forsythia viridissima, 1844
Gardenia jasminoides (cape jasmine)
Gentiana scabra (rough gentian) (see p. 17)
Ginger plant (mentioned as a spice by Confucius)
Hemerocallis fulva (orange day lily)
Hydrangea, 1789 (see p. 15)
Ixora

Jasminum nudiflorum (winter jasmine), 1844 (see p. 29)
Kerria japonica, 1805
Lilium lancifolium (tiger lily), 1805
Lonicera japonica, 1805
Lycoris radiata
Magnolia denudata (yulan)
Osmanthus fragrans
Paeonia suffruticosa (moutan), 1787
Paeonia arborea (tree peony)
Parthenocissus quinquefolia (Virginia creeper)
Pieris japonica, 1805
Pittosporum tobira, 1805
Polyanthus narcissus (see p. 31)
Primula obconica (primrose)
Prunus (plum) (see p. 35)
Prunus x amygdalo-persica (peach) (see p. 95)
Pyracantha
Quince
Rosa banksiae, 1805
Rubus
Spiraea
Wisteria, 1816 (see p. 32)

A most important species of the *Camellia* is the tea plant, around which many legends have grown. The Buddhist Indian Prince Bodhidharma was supposed to have landed in China in AD 510, intending to convert the natives to Buddhism. Time was short, so he never slept, staying awake permanently by teaching, prayer and meditation. However, one day Ta-Mo, as the Chinese called him, fell asleep and, ashamed of himself, he cut off his eyelids and threw them on the ground. Buddha caused them to sprout, take root and thus become the first tea plant, whose dried leaves resemble the shape of eyelids.

Tea is believed to induce wakefulness, but the beverage itself was reputedly discovered by another Buddhist hermit who, while using branches of the tea plant to make a fire, accidentally dropped some leaves into the pot of boiling water. Finding it pleasant and exhilarating, he made his discovery generally known.

Paintings of some of these flowers and fruit appear throughout the book as indicated by the page numbers.

7 Animal Symbolism

THE CAT

Cats keep the rats away from the silkworms, so pictures of cats were pasted on the wall to ensure that both these predators and evil spirits would be kept at bay. A cat coming to a house is an omen of approaching poverty, while a cat washing its face heralds the arrival of a stranger.

The Cat.

THE DEER

As it is believed to live to a great age, the deer is a symbol of long life. In addition it has powers which enable it to find the sacred *Lung Chih* – the fungus of immortality.

THE DOG

One of the twelve symbolic animals of the Chinese Zodiac, a dog coming into the household presages future prosperity. Paintings of the 'Heavenly Dog' are used as objects of worship in the bedrooms of married women.

Pekinese dogs (*Pai*) were called 'short-legged, short-haired dogs' belonging under the low tables used by the Chinese in ancient times. Because they were lion-like, they were associated with Buddhism.

THE DONKEY

This animal is symbolic of stupidity in China as well as to the Westerner, although it often appears in paintings, pictured on bridges and mountains carrying the travellers' baggage.

A Donkey, carrying its burden in an all black landscape (painted on bamboo paper).

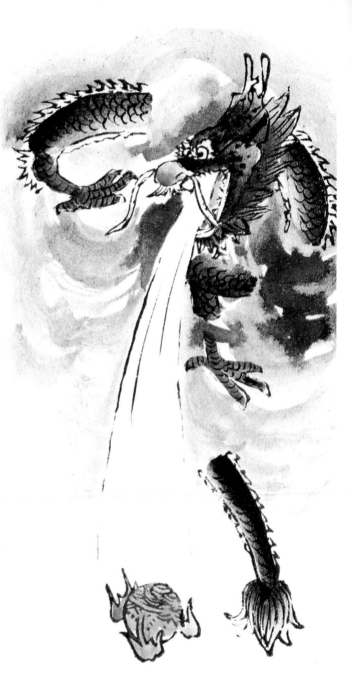

A Dragon in the sky: the 'Lung' with its 'Shining Pearl'.

THE DRAGON

The Eastern dragon is a paragon of strength and goodness and represents life itself. As it covers itself with mud in autumn, then emerges and climbs to the skies in spring, it has become symbolic of the spring season. It is an emblem of vigilance and safeguard.

The '*Lung*' is the most powerful dragon, its home being in the sky. It has nine characteristic comparisons to other creatures:

the head of a camel
the horns of a deer
the eyes of a rabbit
the ears of a cow
the neck of a snake
the belly of a frog
the scales of a carp
the claws of a hawk
the palm of a tiger.

The dragon can be described precisely, having 81 scales in a ridge along its back, whiskers on each side of its mouth and a beard hiding a bright pearl. It is deaf (which is why deaf people are called '*lung*'), and its breath can change from water to fire. There are nine decorative sub-species of dragon, each with its own special characteristics, specially used on carved artifacts.

Dragon Name	Characteristics	Used for carving on:
P'u-lao	cries loudly when attacked	tops of bells and gongs
Ch'iu-niu	taste for music	the screws of fiddles
Pi-hsi	fond of literature	top of stone tablets
Pa-hsia	supports heavy weights	bottom of stone monuments
Chao-feng	likes danger	the eaves of temples
Chih-wen	fond of water	beams of bridges
Suan-ni	likes resting	Buddha's throne
Yai-tzu	lust for slaughter	sword hilts
Pi-kan	likes litigation and quarrel-ling; very fierce	prison gates

The round red object which always appears in dragon paintings has been described over the centuries as: the sun, the moon, the symbol of rolling thunder, the egg of nature, the pearl of potentiality or 'the night-shining pearl', which is a ruby. Since 206 BC, the 5-clawed dragon has been the emblem of imperial power. The Dragon Boat Festival held on the 5th day of the 5th moon is an occasion of great splendour, with boats measuring about 125 feet in length and having 60 or more rowers.

There are no objects of Chinese art or artifacts on which the dragon does not customarily appear. Even in the twentieth century it is one of the most important symbolic elements in Chinese life.

Painted in France during 1914–18 by a Northern Province Chinese enlisted in the Labour Corps.

Two Little Foxes – a modern birthday card.

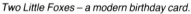

狐狸

THE FOX

This is a supernatural animal and can assume a human shape. At 50 it can become a woman, at 100, a young and beautiful girl or a wizard, while at 1000 years old it is admitted to Heaven, becoming a Celestial Fox – golden in colour and with nine tails. It is regarded as an emblem of longevity and craftiness. Wayside shrines are dedicated to the fox, which is credited with curing disease, and is also a god of wealth.

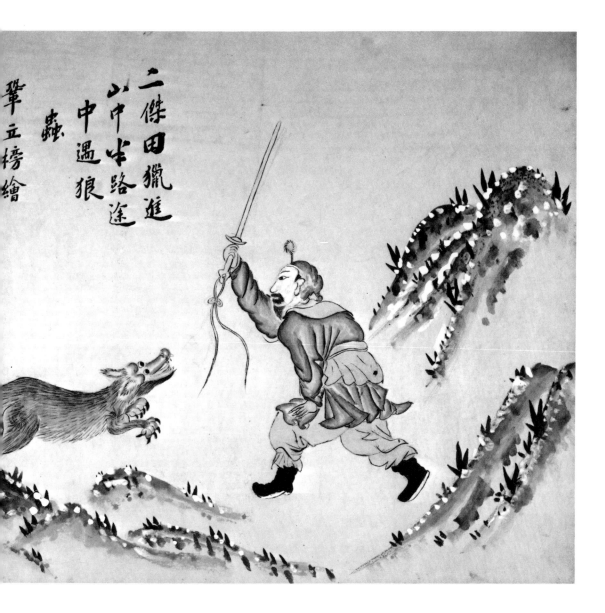

二傑田獵進
山中半路途
中遇狼
蟲

摯立榜繪

THE HARE

The hare is an emblem of longevity, reputed to derive its vital essence from the moon. It is one of the Zodiac signs and can also attain the age of 1000. A red hare appears when the Empire is governed by beneficial rulers.

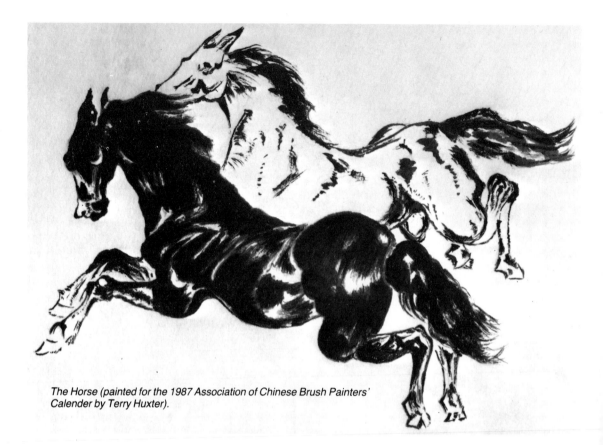

The Horse (painted for the 1987 Association of Chinese Brush Painters' Calender by Terry Huxter).

 THE HORSE

This animal is one of the seven treasures of Buddhism and is the seventh of the twelve Zodiac signs. The character '*ma*' represents the horse which is an emblem of speed and perseverance. The Eight Horses of Mu Wang (1001–746 BC), of which many legends abound, were painted by the most famous of the traditional horse painters, Han Kan (AD 750) and Chao Meng-fu (AD 1254). Manchu officials wore costumes with sleeves shaped like a horse's hoof and adopted the cue of hair imitating the horse's tail as a grateful tribute to the animal which was so important in their lives.

 THE LEOPARD

The leopard or panther is an emblem of bravery and ferocity in war and was used frequently as an embroidered motif for third grade military officials.

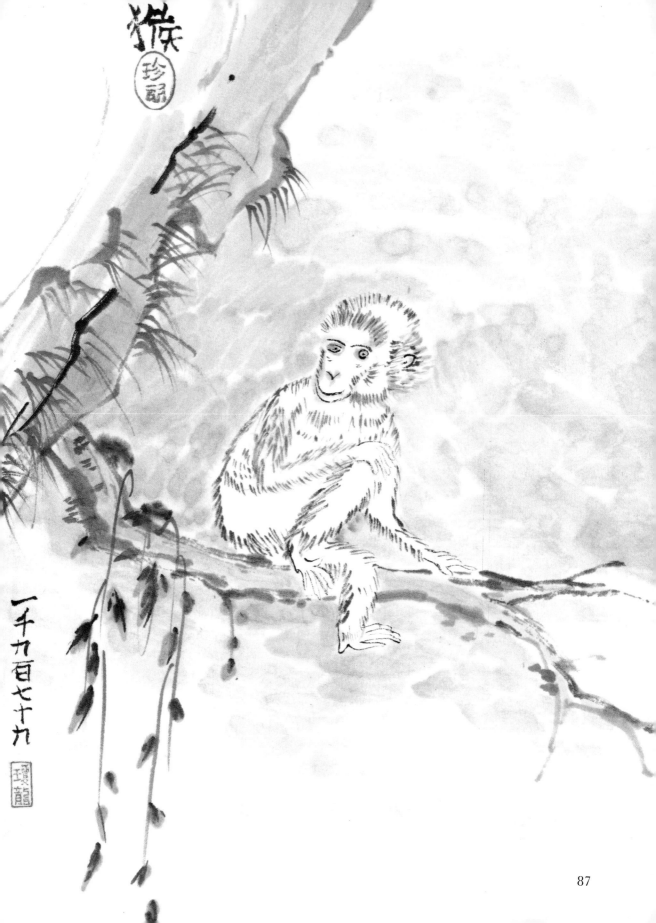

猴
珍藏

一千九百七十九

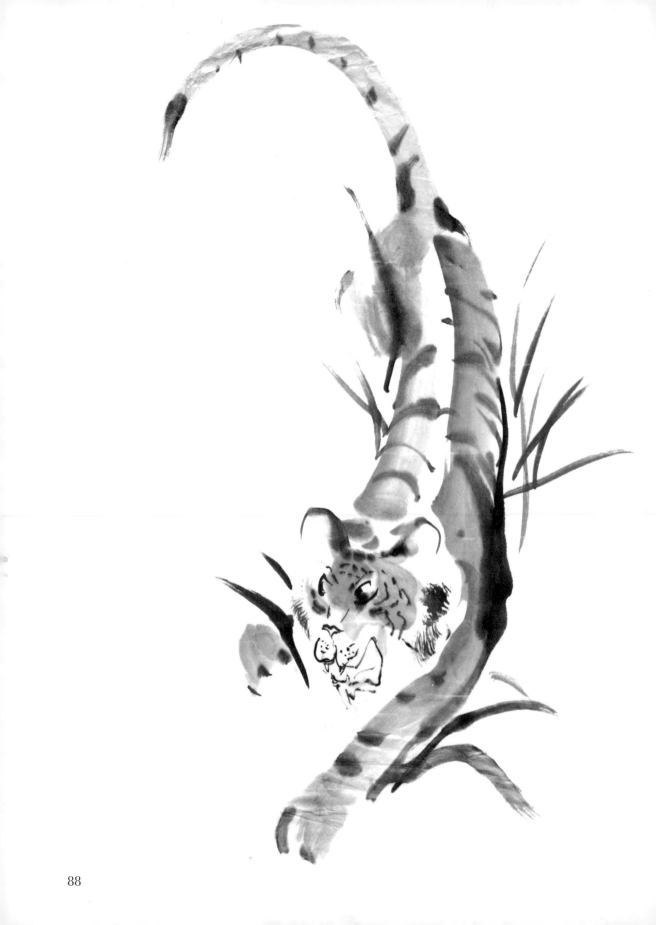

THE LION

This is a Buddhist emblem, defending the law and protecting sacred buildings against demons. It is an emblem of valour and energy and is usually depicted playing with a ball or 'chu'.

THE MONKEY

The monkey is a symbolic animal, although generally known as an emblem of ugliness and trickery. It does keep away harmful magic spirits and because of this is the means of bestowing health, protection and success on the Chinese people.

THE OX

This is the emblem of spring and agriculture and the second animal of the twelve signs of the Zodiac. It also has the power to keep back the evil spirits arising from lakes, rivers and seas.

THE PIG

The pig is the last of the animals of the twelve Terrestrial branches. The wild boar symbolises the wealth of the forest.

THE RAT

The first of the twelve symbolic animals, the rat is a symbol of industry and prosperity. Its flesh, when eaten, is supposed to be a cure for baldness.

THE SHEEP

The sheep or goat (hill-sheep) is the eighth animal of the Zodiac and is an emblem of the retired life, while the lamb is the symbol of filial piety. Canton is called 'the City of Rams' from an ancient legend where magicians riding these beasts appeared to avert famine.

THE SNAKE

One of the Zodiac signs, the snake is the emblem of cunning and evil, but because of its friendship with the dragon and its supernatural powers, it is regarded with awe and veneration.

THE TIGER

To the Chinese, the tiger is the king of the wild beasts and lord of all land animals; it is symbolic of dignity, a model for courage and fierceness. Its head was painted on shields, embroidered on court robes, used as an ornament on bronzes and ceramics and painted on walls to frighten dangerous spirits away. A powerful zodiac sign.

THE TORTOISE

This important reptile, sacred to China, is an emblem of long life, strength and endurance. Tortoises are often kept in tanks at Buddhist temples. They symbolise the universe to the Chinese and are regarded as having a spiritual nature. The upper part of the shell has markings representing the constellations and Yang, while the lower shell, with earth markings, is Yin. Some Chinese believe that the shell markings were the inspiration for the first characters.

THE UNICORN

This is a fabled creature of good omen, symbolising long life, greatness, wise administration and famous children. It is reputed to be able to walk on water as well as on land, its last appearance being just prior to the death of Confucius. Everything that is good is embodied in the unicorn, the noblest of beasts. The male is called '*ch'i*' and the female '*lin*'. Its skin embodies the five colours: red, yellow, blue, white and black. It was often embroidered on the military court robes of the first grade officials.

The four great mythical animals of China are the dragon, the phoenix, the tortoise and the unicorn.

8 Fruit Legends and Symbolism

The Chinese have a vivid imagination which has helped both to transmit and enhance the wealth of legendary material derived from their ancient historical background. These legends and symbolic meanings impinge on the literature and art as well as the work and daily life of the Chinese.

Because of the Chinese people's love of nature, natural objects, either singly or in combination, embody legends and symbolism which are still as important today as they were in centuries past. Modern New Year cards, congratulatory messages, ceramic decorations and paintings are more than merely decorative, they contain the underlying messages of ancient gods, beliefs and superstitions. All Chinese life is permeated with legends and folklore, much of it derived from the three main religions of Taoism, Confucianism and Buddhism.

Flower and bird symbolism was described in some detail in *How to Paint The Chinese Way*, published by Blandford Press, 1979; the following sections expand on Chinese symbolism in the mythology of animals and fruit in paintings.

Cherries on a Plate

THE APPLE

Only the wild crab-apple and cherry apple are found in China, with the blossom being used decoratively to represent female beauty. Because the sound of the Chinese word for apple, *'ping'*, is similar to that of peace, the gift of apples means 'peace be with you'.

THE APRICOT

Grown on the Chinese hillsides, the edible almond-shaped kernels are compared to the eyes of Chinese ladies.

THE CHERRY

Smaller than the western fruit, too sour to be eaten raw, the brilliant red of the cherry was used by the poet Chui-i to describe the colour of the lips of a famous concubine and so has become symbolic of a beautiful woman.

THE GOURD

When dried the bottle gourd is used as a watertight container for medicines and so has become a shop-sign on Chinese drug stores. Because medicine has always been associated with necromancy, the gourd has become an emblem for one of the eight Taoist gods. Charms, made of wood or metal, featuring an old man with a gourd on his back are worn to assure long life. Paintings and papercuts of gourds, or gourd-shaped lanterns, help ward off evil influences.

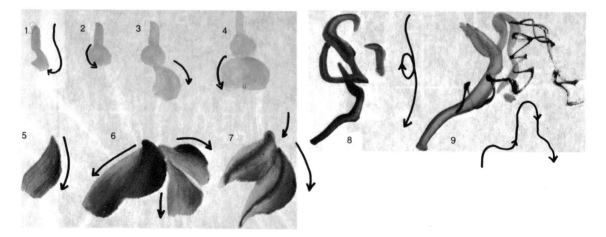

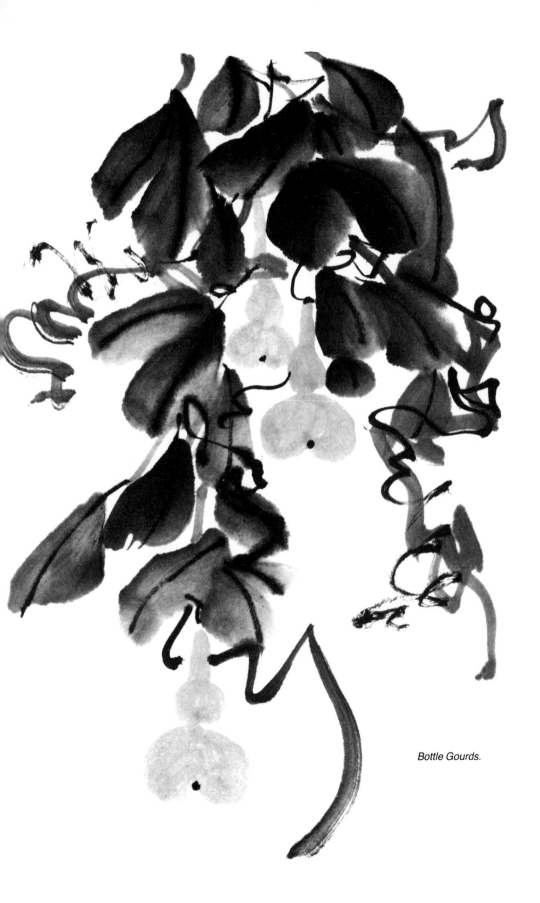

Bottle Gourds.

 GRAPES

Introduced into China in 126 BC, grapes are a popular art motif as a decorative pattern for borders or paintings. Grapes often feature in compositions with squirrels or in baskets.

 THE ORANGE

This fruit was used in imperial sacrifices at the start of the year, and amongst ordinary people denotes a wish for abundant happiness and prosperity.

 THE PEAR

In 1053 BC the Duke of Shou sat under a wild pear tree to administer justice to his people and the tree was preserved in memory of his fair judgements. Since that time the pear has become symbolic of wise and good government. Since the pear tree is also known to be long-lived and has been recorded as still bearing fruit when 300 years old, it has also become symbolic of longevity.

Ming Huang conceived his idea of a college of music in the eighth century AD while sitting in a pear orchard and so since that time musicians and actors have been known as 'brethren of the pear-orchard'.

 THE PERSIMMON

Sometimes called a date-plum or Chinese fig, the persimmon has become symbolic of joy because of its bright colour. It looks like a light red apple and is generally painted hanging heavily from a small twig.

 THE PLANTAIN

The plantain tree, growing fifteen to twenty feet high, is popular for its nutritional fruit and large shady leaves. An ancient legend concerning a student, too poor to buy materials, who used the plantain's leaves to write on, was the inspiration for this tree to become symbolic of self-education.

THE PEACH

Sometimes called 'Fairy Fruit', peaches are prolific in China, where they originated. The right half of the character for Peach means 'million'. It is an emblem of marriage and a symbol of immortality and springtime. (It also has a joint symbolism with the plum.)

Peaches in a Basket.

THE PLUM

Students are sometimes called 'peaches and plums' as they are like unripe fruit receiving their development from the teacher.

The plum is the symbol of winter: the white, sweet-smelling blossom inspiring great poetry and paintings. It is also symbolic of long life as flowers grow on what appear to be old, lifeless branches, and, indeed, Lao Tsu, the founder of Taoism, was also said to have been born under a plum tree.

Plum blossom, with its five petals representing the five main Chinese groups – Chinese, Manchus, Mongolians, Mohammedans and Tibetans, is the national flower of the Chinese Republic.

Legends speak of instances where thirsty Chinese were ordered to think of juicy plums so that their mouths would water, thus giving rise to the expression 'gazing on plums to quench thirst' which is the Chinese version of 'sour grapes'.

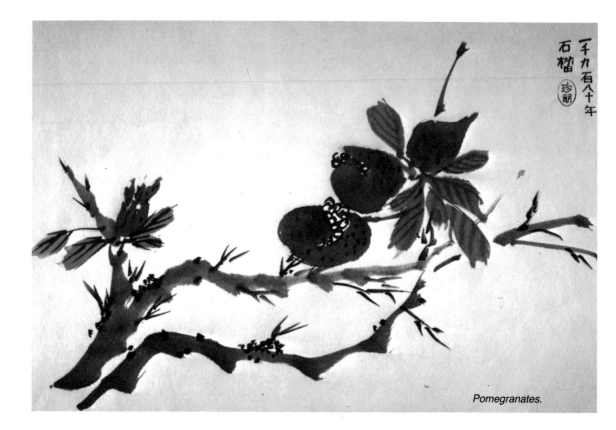

Pomegranates.

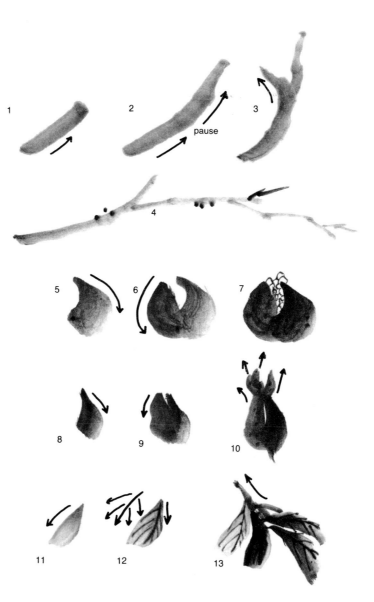

石榴

THE POMEGRANATE

This fruit is a Buddhist symbol, while the twigs of the shrub are used to sprinkle water in the temple ceremonies. Taoists occasionally use pomegranates as a substitute for peaches in their religious ceremonies. Because the brilliant red fruit bursts open, revealing the huge collection of seeds, it has become symbolic of fecundity.

The flowers, single and double blossoms, vary in colour from white to pale pink and dark red, and can be used as the basis of a hair-dye. The dried fruit peel is an astringent, a remedy for rheumatism and part of the treatment for dysentery and eye-diseases.

CHERRIES ON A PLATE

Colours: red, black, green
Brushes: medium and fine
Order: cherries, dish, stems
Steps:

1. Cherries are painted with red, using a medium brush, in one stroke, as close together as possible, with some half shapes to make the composition more interesting.
2. With medium brush and grey, paint the bowl outline, which can then be given a pale green wash.
3. When the cherries are dry, load a fine brush with black, and paint each stem in one quick, positive stroke, each with a dot added to the end.

BOTTLE GOURDS

Colours: yellow and black
Brushes: medium and fine
Order: gourds, leaves, vines, vine tendrils
Steps:

1–4. With a medium brush loaded with yellow paint the strokes from the top downwards, as this is the direction in which the gourd hangs. When the yellow gourd is dry, use the small brush loaded with black to add the dots.
5–7. Using a medium brush, paint the leaves in grey in groups near the gourds. Do not let the composition become too wide. Single black veins are sufficient for these leaves.
8. With a medium brush loaded with dark grey, paint the vines from the growing points at the top of the composition.
9. With black ink on the fine brush paint the tendrils, which can also be used to join the leaves and gourds to the hanging stems.

PEACHES IN A BASKET

Colours: yellow, red, black, green
Brush: medium
Order: fruit, basket, leaves if needed
Steps:

1. Load the brush in yellow, tipped with red. The stroke is made by putting the point only on the paper at the start

and finishing with all the bristles on the paper.

2. Make the fruit round with the second stroke.

3. If needed, dry red brush strokes can be added immediately while the fruit is still wet.

4–6. Similar shapes can be made with the brush loaded with yellow and tipped with green, making the first stroke on the right side and then finally adding the black stalk.

7–8. Using the brush loaded with grey, but without washing the remaining yellow from the bristles, make the basic hoop shapes for the top of the basket and the handle.

9. Left to right dashes, staggered in rows, will construct the cane basket itself.

10. Leaves can be added either in the basket or separately as part of the general composition.

POMEGRANATE

Colours: red, crimson, black
Brushes: medium and fine
Order: stems, pomegranates, leaves
Steps:

1. With medium brush loaded with grey (black with water) paint brush strokes for stems.

2. Let the brush pause in mid-stroke to thicken the branch.

3. Add the side branches.

4. Add black dots and small twigs.

5. With medium brush loaded with red, and point at the top, allow all the bristles to lie on the paper to make the right hand stroke.

6. Make left side stroke.

7. With fine brush, make scarlet dots on wet pomegranate, then add small lines for the individual segments bursting out of the fruit.

8. For the buds, use a medium brush in a similar manner to that used for the large fruit but without using the full length of the bristles. (9)

10. Use a medium brush loaded in grey, but with traces of the red still left in the unwashed brush. Add small unformed leaves to the top.

11. With the fine brush add the vein lines in black.

12. With the medium brush, put short stems onto the groups of leaves in grey. Leaves can also be painted in green.

9 Chinese Zodiac

Chinese mythology explains the Zodiac signs as the result of
a meeting called by Buddha to organise the Chinese year.
Although he asked all the animals to come to the meeting, only
twelve actually appeared, so a year was allocated to each of the
animals in order of their appearance, the Rat arriving first and
the Pig last.

The Chinese take their horoscopes very seriously, consulting
fortune tellers before embarking on any new project. The Zodiac
order is as follows, with the years for the twentieth century listed
next to each animal

RAT	1900	1912	1924	1936	1948	1960	1972	1984	1996
OX	1901	1913	1925	1937	1949	1961	1973	1985	1997
TIGER	1902	1914	1926	1938	1950	1962	1974	1986	1998
RABBIT/CAT	1903	1915	1927	1939	1951	1963	1975	1987	1999
DRAGON	1904	1916	1928	1940	1952	1964	1976	1988	2000
SNAKE	1905	1917	1929	1941	1953	1965	1977	1989	
HORSE	1906	1918	1930	1942	1954	1966	1978	1990	
GOAT or SHEEP	1907	1919	1931	1943	1955	1967	1979	1991	
MONKEY	1908	1920	1932	1944	1956	1968	1980	1992	
ROOSTER	1909	1921	1933	1945	1957	1969	1981	1993	
DOG	1910	1922	1934	1946	1958	1970	1982	1994	
PIG	1911	1923	1935	1947	1959	1971	1983	1995	

As each year of the twelve year cycle begins with Chinese New
Year, which varies from early January to mid-February, those
with birthdays in these two months will have to check carefully
to see which sign is individually appropriate to them. For
instance 20 Jan 1960 will be the sign of 1959 (the Pig) not 1960
(the Rat).

The character projected for the twelve animals is as appro-
priate to the westerner as it is for those born in the east. The
characteristics which follow are only a short general summary
of each of the year's behavior traits, based on the person's year
of birth.

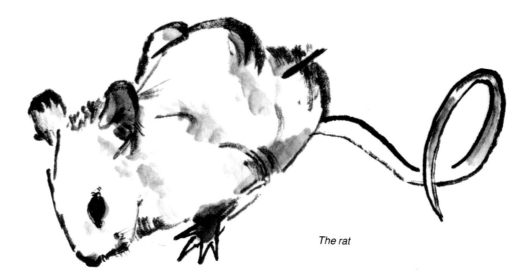

The rat

THE RAT

Symbolic of shyness, diligence, prosperity and malice.
Chinese name: *SHU*. Special month: December. Special hours:
11pm to 1am.
Rats are honest but greedy

> generous but petty
> charming but tiresome
> seductive but suspicious
> energetic but destructive
> meticulous but manipulative
> sociable but power-hungry
> persistent but agitative
> humorous but gamblers
> intellectual but disquietful
> honest but profiteering

They are lovable sentimental people but have rather two-sided characters, giving outward signs of generous jollity but being selfish and greedy inside. Often they are 'do-gooders' but complain a lot about the efforts of others, making them difficult people to work with. They love good food and are excellent bargain hunters.

The Years of the Rat

31 January 1900 to 19 February 1901
18 February 1912 to 6 February 1913
5 February 1924 to 25 January 1925
24 January 1936 to 11 February 1937
10 February 1948 to 29 January 1949
28 January 1960 to 15 February 1961
15 February 1972 to 2 February 1973
2 February 1984 to 19 February 1985
19 February 1996 to 6 February 1997

The ox

THE OX

Symbolic of spring, agriculture, man in charge of nature, truth in action.

Chinese name: *NIU*. Special month: January. Special hours 1am to 3am.

Oxen are family orientated but jealous

hardworking but resistant to change
methodical but slow
leaders but bad losers
proud but stubborn
precise but rigid
eloquent but conventional
self sacrificing but misunderstood
original but authoritarian
strong but vindictive

They are patient, reserved people who can be counted on in a crisis, and who achieve their goals by steady plodding.

The Years of the Ox

19 February 1901 to 8 February 1902
6 February 1913 to 26 January 1914
25 January 1925 to 13 February 1926
11 February 1937 to 31 January 1938
29 January 1949 to 17 February 1950
15 February 1961 to 5 February 1962
3 February 1973 to 22 January 1974
20 February 1985 to 8 February 1986
7 February 1997 to 27 January 1998

THE TIGER

Symbolic of military prowess, scarer of evil spirits, god of prosperity and military strength.
Chinese name: *HU*. Special month: February. Special hours: 3am to 5am.

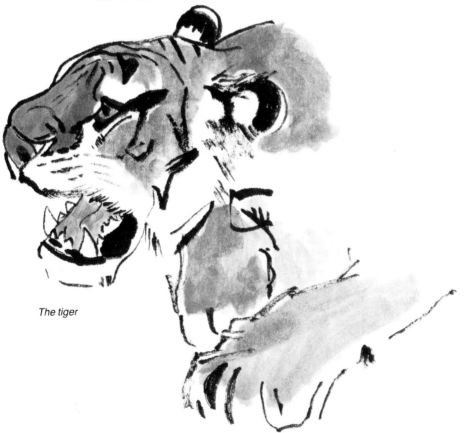

The tiger

Tigers are generous but rash

> self assured but disobedient
> lucky but hasty
> strong but stubborn
> authoritative but uncompromising
> sensitive but quarrelsome
> passionate but hot headed

Tigers have magnetic powerful personalities which attract followers, as they never seem to rest. They are foolhardy but lucky.

The Years of the Tiger

> 8 February 1902 to 29 January 1903
> 26 January 1914 to 14 February 1915
> 13 February 1926 to 2 February 1927
> 31 January 1938 to 19 February 1939
> 17 February 1950 to 6 February 1951
> 5 February 1962 to 25 January 1963
> 23 January 1974 to 10 February 1975
> 9 February 1986 to 28 January 1987
> 28 January 1998 to 15 February 1999

THE RABBIT

(Sometimes the CAT.) Symbolic of long life and the moon. Chinese name: *TU*. Special month: March. Special hours: 5am to 7am.

Rabbits are discreet but aloof

> sociable but dilettante
> sensitive but squeamish
> ambitious but devious
> prudent but fainthearted
> virtuous but old-fashioned
> clever but pedantic

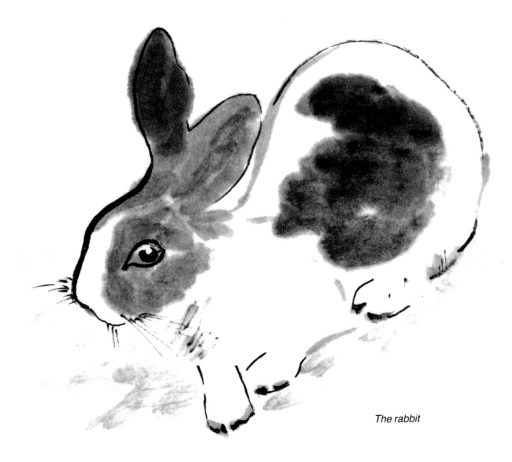

The rabbit

The Years of the Rabbit

29 January 1903 to 16 February 1904
14 February 1915 to 3 February 1916
2 February 1927 to 23 January 1928
19 February 1939 to 8 February 1940
6 February 1951 to 27 January 1952
25 January 1963 to 13 February 1964
11 February 1975 to 30 January 1976
29 January 1987 to 16 February 1988
16 February 1999 to 4 February 2000

THE DRAGON

Symbolic of imperial power, strength, kindness, change, alertness and protection.

Chinese name: *LUNG*. Special month: April. Special hours: 7am to 9am.

Dragons are sentimental but easily infatuated

> enthusiastic but demanding
> intuitive but judgmental
> shrewd but irritable
> spirited but stubborn
> influential but wilful
> generous but loud-mouthed
> artistic but otherworldly
> lucky but impetuous
> successful but malcontent

Dragons consider themselves as superior beings, captivating the attention of ordinary folk by the vitality of their domination.

The Years of the Dragon

16 February 1904 to 4 February 1905
3 February 1916 to 23 January 1917
23 January 1928 to 10 February 1929
8 February 1940 to 27 January 1941
27 January 1952 to 14 February 1953
13 February 1964 to 2 February 1965
31 January 1976 to 17 February 1977
17 February 1988 to 17 February 1989

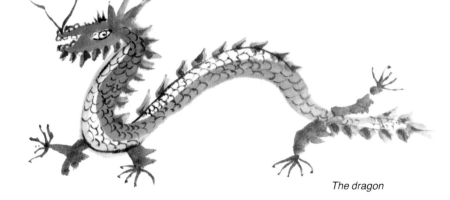

The dragon

THE SNAKE

Symbolic of flattery, malice, cunning and supernatural powers with the dragon.

Chinese name: *SHE*. Special month: May. Special hours: 9am to 11am.

Snakes are wise but phlegmatic

accommodating but tight-fisted
intuitive but self-critical
attractive but ostentatious
amusing but presumptuous
lucky but lazy
sympathetic but fickle
elegant but extravagant
compassionate but vengeful
philosophical but sore-losers
calm but possessive

Snake people are alluring and magnetic, hardly ever ruffled, with many talents and also many character weaknesses.

The Years of the Snake

4 February 1905 to 25 January 1906
23 January 1917 to 11 February 1918
10 February 1929 to 30 January 1930
27 January 1941 to 15 February 1942
14 February 1953 to 3 February 1954
21 February 1965 to 21 January 1966
18 February 1977 to 6 February 1978
6 February 1989 to 26 January 1990

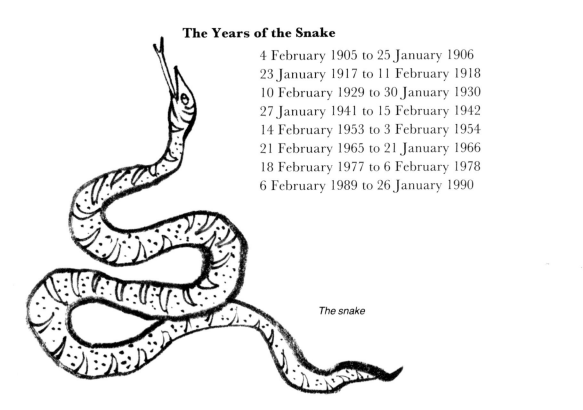

The snake

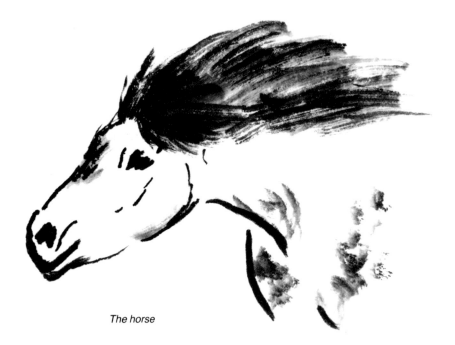

The horse

 THE HORSE

Symbolic of speed and endurance
Chinese name: *MA*. Special month: June. Special hours: 11am to 1pm.
Horses are amiable but weak

> eloquent but hot-headed
> self-possessed but pragmatic
> quick-witted but tactless
> charming but selfish
> independent but rebellious
> powerful but ruthless
> hardworking but impatient
> jolly but foppish
> sentimental but unfeeling
> sensual but predatory

Horse people are pleasant, likeable people, hardworking and independent, who believe they are superior. Always on the move, taking their personal image very seriously, they keep busy making things, socialising or politicking.

The Years of the Horse

25 January 1906 to 13 February 1907
11 February 1918 to 1 February 1919
30 January 1930 to 17 February 1931
15 February 1942 to 5 February 1943
3 February 1954 to 24 January 1955
21 January 1966 to 9 February 1967
7 February 1978 to 27 January 1979
27 January 1990 to 14 February 1991

THE SHEEP

Sometimes called the GOAT. The sheep is the emblem of a retired life, while the lamb is symbolic of filial piety.
Chinese name: *YANG*. Special month: July. Special hours: 1pm to 3pm.
Sheep are creative but fussy

intelligent but pessimistic
well-mannered but unpunctual
sweet-natured but dependant
inventive but irresponsible
lovable but capricious
artistic but dissatisfied
amorous but undisciplined
malleable but insecure

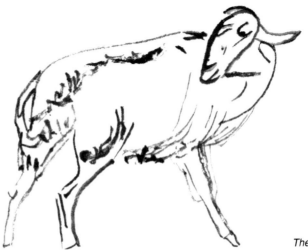

The sheep

Sheep or goat people do best what comes naturally without routine or rules, but they are capricious and eccentric. They need to be loved and looked after while they daydream.

The Years of the Sheep

13 February 1907 to 2 February 1908
1 February 1919 to 20 February 1920
17 February 1931 to 6 February 1932
5 February 1943 to 25 January 1944
24 January 1955 to 12 February 1956
9 February 1967 to 29 January 1968
28 January 1979 to 15 February 1980
15 February 1991 to 3 February 1992

THE MONKEY

Symbolic of skill and humour.
Chinese name: *HOU*. Special month: August. Special hours: 3pm to 5pm.
Monkeys are very intelligent but dissimulating

witty but vain
affable but longwinded
good at business but tricky
enthusiastic but opportunistic
passionate but unfaithful
fascinating but untrustworthy
clever but unscrupulous

The monkey

Monkeys are bright, funny and sociable but devious and mischievous. Marriage and family life can be very complicated for them. They are full of enthusiasm for 'grand projects', usually with selfish motivation.

The Years of the Monkey

> 2 February 1908 to 22 January 1909
> 20 February 1920 to 8 February 1921
> 6 February 1932 to 26 January 1933
> 25 January 1944 to 13 February 1945
> 12 February 1956 to 31 January 1957
> 29 January 1968 to 16 February 1969
> 16 February 1980 to 4 February 1981
> 4 February 1992 to 22 January 1993

THE ROOSTER

Symbolic of the Five Virtues: literary, warlike, courageous, benevolent, faithful. A rooster on a roof is a bad omen. Chinese name: *Ji*. Special month: September. Special hours: 5pm to 7pm.

The rooster

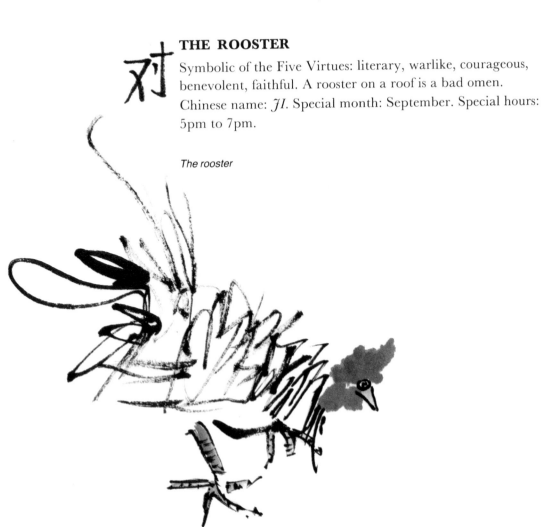

Roosters are resourceful but spendthrift

> courageous but braggarts
> talented but pompous
> generous but quixotic
> adventurous but mistrustful
> industrious but nit-picking
> enthusiastic but short-sighted
> amusing and attractive but acid-tongued
> contemplative and conservative but pedantic

Life fascinates and amuses roosters, who love to travel and try new life styles. They strut about enjoying each day as though it were the last, getting on with trivial tasks in their own way, regardless of rules and regulations. They love challenges to their creativity.

The Years of the Rooster

> 22 January 1909 to 10 February 1910
> 8 February 1921 to 28 January 1922
> 26 January 1933 to 14 February 1934
> 13 February 1945 to 2 February 1946
> 31 January 1957 to 16 February 1958
> 17 February 1969 to 5 February 1970
> 5 February 1981 to 24 January 1982
> 23 January 1993 to 9 February 1994

THE DOG

Symbolic of the future and wealth.
Chinese name: *GOU*. Special month: October. Special hours: 7pm to 9pm.
Dogs are magnanimous but stubborn

> courageous but defensive
> loyal but critical
> devoted but guarded
> selfless and faithful but moralising
> modest but forbidding
> prosperous but cynical
> philosophical but pessimistic
> intelligent but introverted

Dogs are watchful and suspicious but honourable in themselves and not self-seeking. Injustice inspires these people, who continue to be unsure of themselves, being pessimistic and cautious in all things.

The Years of the Dog

10 February 1910 to 30 January 1911
28 January 1922 to 16 February 1923
14 February 1934 to 4 February 1935
2 February 1946 to 22 January 1947
16 February 1958 to 8 February 1959
6 February 1970 to 26 February 1971
25 January 1982 to 12 February 1983
10 February 1994 to 30 January 1995

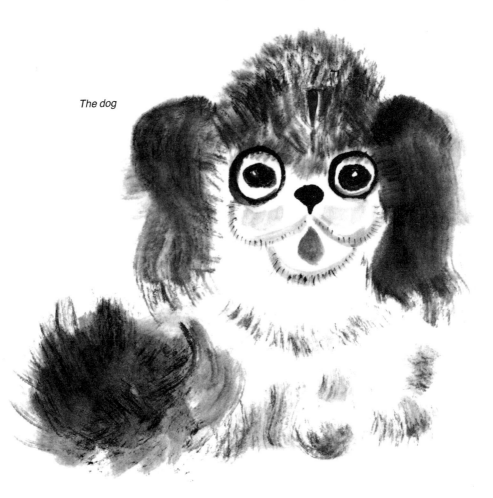

The dog

THE PIG

Symbolic of the richness of the forest.

Chinese name: *ZHU*. Special month: November. Special hours: 9pm to 11pm.

Pigs are obliging but gullible

> loyal and impartial but defenceless
> indulgent but wilful
> intelligent but non-competitive
> sincere but easy prey
> sociable but insecure
> cultured but sardonic
> sensual but earthy
> loving but naïve

Pigs are likeable upstanding citizens, but sometimes too good to be true. They are often sensitive intellectuals who work hard but lose out because they are too kind-hearted.

The Years of the Pig

> 30 January 1911 to 18 February 1912
> 16 February 1923 to 5 February 1924
> 4 February 1935 to 24 January 1936
> 22 January 1947 to 10 February 1948
> 8 February 1959 to 28 January 1960
> 27 January 1971 to 14 February 1972
> 13 February 1983 to 1 February 1984
> 31 January 1995 to 18 February 1996

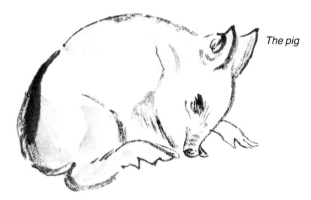

The pig

10 Famous Chinese Painters

Chinese painting is generally considered as being divided into two schools, the Northern and the Southern. This also approximates to the division between the careful court paintings and the free brush work of the literary artists. It is the second group, the Southern School painters, who prize spontaneity and speed, who are now regarded as the producers of paintings regarded as typically Chinese. The careful painting of the Northern School is necessary for the representation of people or palace buildings, but landscape, flowers, animals and more natural elements are best achieved by free brushwork.

Table 1 shows how the popularity of painting topics ebbed and flowed over the centuries. Portraits predominated as a painting subject up to the Tang dynasty, overlapped by the

Hui Tsung. Birds and Flowers.

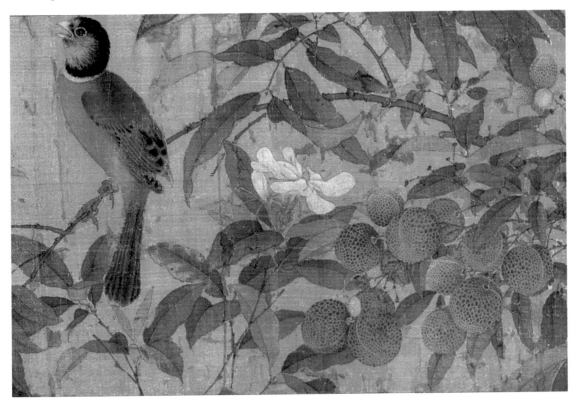

dominance of religious subject matter, highlighted by Buddhist paintings, stone work and the frescoes of Tun-Huang.

Landscape painting in all its aspects began in the fifth century AD, increasing in popularity and reaching its zenith in the Five Dynasties. From that time to the present day it has retained its position as the most important subject in traditional Chinese painting.

It was also during the tenth century that the art of painting nature, birds, animals and insects, reached a high point, eventually taking over the popular place previously held by portrait painting.

One of the reasons for the increase in the popularity of 'nature-based' subjects was the quick-brush concept of painting developed by scholar painters. The most popular subjects initially were 'the Four Gentlemen' – bamboo, orchid, plum and chrysanthemum – all subjects lending themselves to expressionistic vibrant brushwork. Many of these painters were also poets.

Some responsibility for the development of splashed-ink painting, however, came as a result of the *Ch'an* form of Buddhism (known in Japan as Zen). Believers considered that enlightenment came in a sudden flash and therefore painting should also express the immediacy of inspiration. This type of ink painting widened the scope of Chinese art and has had a great influence on modern painters.

The most famous of the many painter emperors was Hui Tsung of the Sung dynasty, but he was not the only ruler who encouraged painting, poetry and calligraphy. The atmosphere of the courts was such that it stimulated creativity and encouraged painters, although occasionally an Emperor would have very fixed ideas about art and creative talent would be stifled in favour of the court sycophants.

Painters famous in their own time were accorded the accolade of the title 'Master', usually then forming their own schools. Two of the great Sung masters were Ma Yuan and Hsia Kuei, famous for their landscapes. Ma Yuan and to a lesser extent his son, Ma Lin, had a very distinctive style of diagonal composition (Ma Yuan was nicknamed 'One-Corner Ma') which generated in the viewer a feeling of peace and tranquillity. Table 2 gives the names of some of the famous painters as they occur over the centuries of development.

Other artists not mentioned, but famous for their expres-

sionistic paintings, are Chang Tsao, Wang Hsia, Wen T'ung, Chin Nung, Cheng Hsieh, Hsu Pei-hung and Chang Ta-ch'ien.

The Chinese are admirers of tradition and appreciators of individuality, but they also expect the artist to understand

Development of the Popularity of Painting Topics

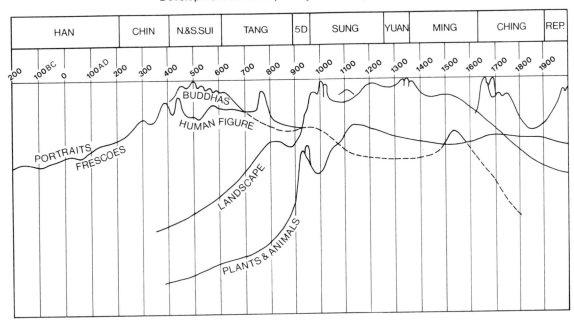

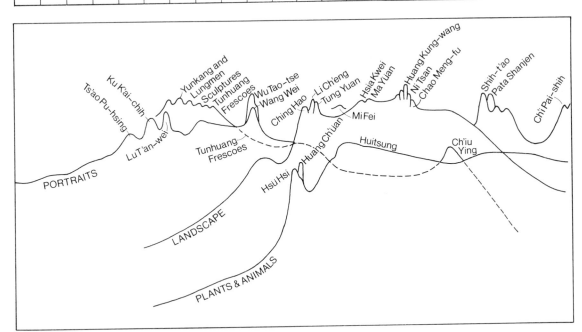

Famous Chinese Painters

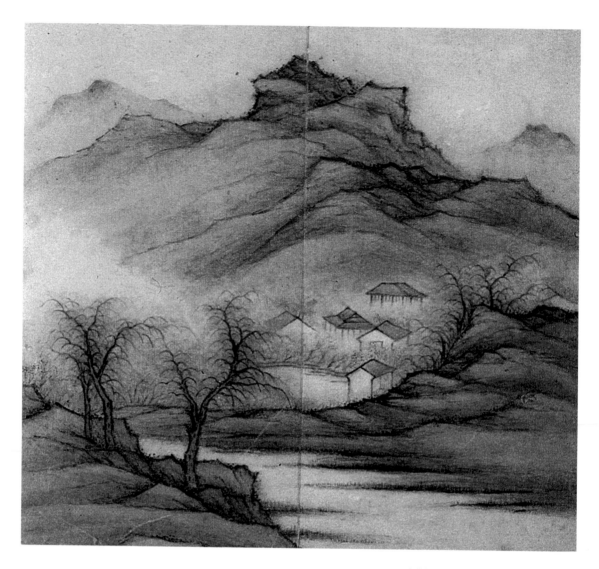

A 'blue-green landscape' by Kung
Hsien, a painter who never included
people in his album leaf
compositions.

something of their artistic heritage. They like to see an artist who carries forward into his or her work some small bond from the past, a part of the cultural tradition. Indeed, worship of the ancients was taken for granted and copying from the work of old masters was an accepted element of the learning process for the developing painter.

The Chinese description for this process is '*shih*' which means 'take for master' or more realistically, 'model oneself upon'. Chinese painters usually make an in depth study of the master's style, be he or she an ancient or a contemporary; they endeavour to model recognisably some, at least, of their own technique on this artist. It would not be satisfactory to use only one model as this would be inhibiting. Several 'masters' forming the basis of an artist's techniques eventually results in the development

Chart of Derivations

N. & S. DYNASTIES AD 317–	TANG 618–	FIVE DYNASTIES 907–	SUNG 960–	YÜAN 1277	MING–CHING 1368–1911
		EXPRESSIONISTS			Shih-t'ao / Pata Shanjen
Chang Seng-yu	Wu Tao-tse / Chang Tsao		Su Tung-p'o / Wen T'ung / Mu-ch'i / Liang K'ai		Ch'en Ch'un / Hsü Wei / Cheng Hsieh / Chin Nung / Ch'i Pai-shih / Hsü Pai-hung
⌐Cheng Fa-shih					
	Wang Hsia	*TONALISTS*	Mi-Fei / ⌐Mi Yu-jen / ⌐Li Ti	Kao K'o-kung / Fang Ts'ung-yi	Kung Hsien
			Hsia Kwei / Ma Yüan / Ma Lin	Chao Meng-fu / Ni-Tsan	Tai Chin / ⌐Wu Wei / ⌐Lan Ying
Ku K'ai-chih / Lu T'an-wei / Tung Po-jen / Chan Tse-ch'ien	Yen Li-pen / Li Sze-hsün / Li Chao-tao	*REALISTS*	Li T'ang / ⌐Chao Po-chü / ⌐Liu Sung-nien / Li Kung-lin / Kuo Chung-shu		⌐T'ang Yin / ⌐Ch'iu Ying
		IMPRESSIONISTS / Li Ch'eng	Kao K'o-ming / Kuo Hsi / Wang Shen / ⌐Hsü Tao-ning / ⌐Fan K'uan	Wang Meng	⌐Wu Li
	Wang Wei	Ching Hao / ⌐Kuan T'ung / ⌐Tung Yüan / ⌐Chü-jan		Huang Kung-wang / Wu Chen	⌐Wang Shih-min / Wang Chien / Wang Hui / Wang Yüan-ch'i / ⌐Shen Chou / Wen Cheng-ming / Tung Ch'i-ch'ang

119

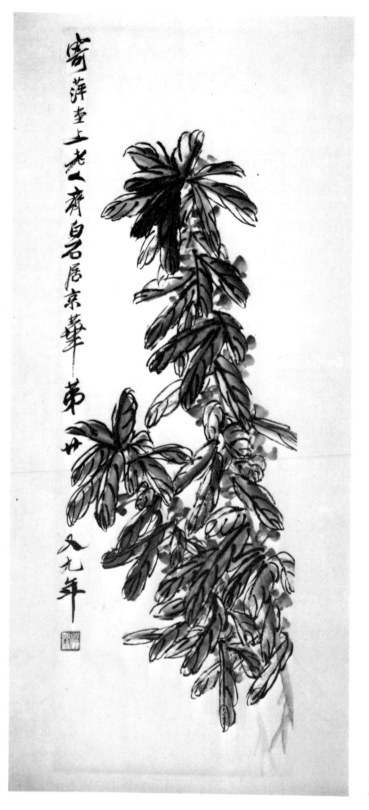

Chi Pai Shih (Qi Baishi) 1863–1957. Blue Blossom. Hanging Scroll. Ink and colours on paper. 100.8 × 34cm.

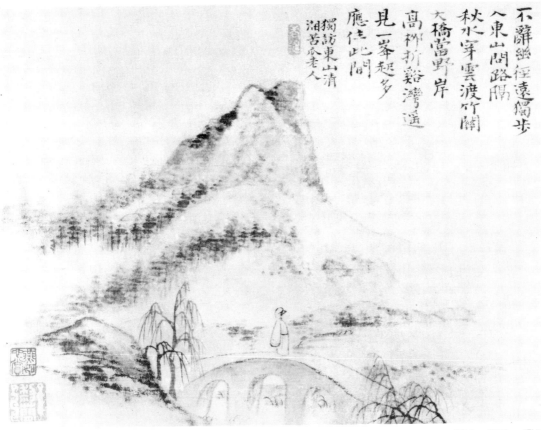

不辭羸徑遠獨步
入東山問路隔
秋水寧雲渡竹關
大橋當野岸
高柳折谿灣道
見一峯越多
應佳此間
獨訪東山清
湖苦瓜老人

Shih-tao (Tai Chi) (Daoji). Album leaf. Ink and colours on paper. 20.3 × 27.5cm. This is the first album leaf in a book of 8. The landscape shows a man on a bridge, with rocks.

of the new artist's individual style, albeit an amalgam or co-ordinated result. The table below shows how the work of some painters can be traced directly back to their influential masters, while others have used inspiration from a variety of painting forbears. No secret is made of these affiliations. Chi Pai-shih, for instance, perhaps the most well-known and most often pictured of twentieth century painters, famous for his flowers, birds and insects (1863–1957), owes much to Shih-t'ao (1641–*c*1717) and Pata Shan-jen (1625–*c*1705).

ROMANISATION OF CHINESE

A confusing situation exists for those who are not Chinese scholars, but are interested in reading about Chinese painters. Depending upon the age and/or the writer of a particular book, the names of the painters may be entirely different. For instance, the painter 'Chi Pai Shih' is now referred to as 'Qi Baishi'. Peking has become known as Beijing.

It is some help to know how this situation occurred. In the early seventeenth century some Jesuits in China began attempts to romanise the Chinese language. The most widely used system was published by Sir Thomas Francis Wade in 1859. It was comparatively simple and based on the Peking dialect, but only attained general use after Herbert A. Giles published his Chinese-English Dictionary in 1892. This sytem, which came to be known as the 'Wade-Giles system', has been widely used in documents and publications and consequently is still operative in most libraries which tend to house old collections. Exceptionally, the Department of Oriental Manuscripts and Printed Books in the British Library has catalogued all its post 1965 books on the other system, which is called *Pinyin*.

Hanyǔ Pinyīnfǎ, always referred to as *Pinyin*, was put forward by the Chinese Ministry of Education in 1928 and approved by the National People's Congress in 1958. The Prime Minister, Chou En-lai explained the functions of *Pinyin* as

a) to give pronunciation to Chinese characters
b) to transcribe Modern Standard Chinese (the common speech) as a basis for teaching and learning
c) as a basis for China's national minorities to reform their written languages
d) to help foreigners learn Chinese and thereby promote cultural exchange

These are the two main systems used for the romanisation of Chinese and it would seem that both will have to continue to exist side by side for some time as the Wade-Giles system has the largest range of reference works, records and geographical publications, while *Pinyin* now has increasing international use due to its status as the official system of the People's Republic of China.

Ding Liangxian. Flowers and Burning Incense. Woodcut. 35 × 27.5cm.

Some examples of syllable conversions which may be useful for students of Chinese painters.

Wade-Giles	Pinyin
cha	zha
chai	zhai
chang	zhang
chao	zhao
che	zhe
chen	zhen
cheng	zheng
chi	ji
ch'i	qi
chia	jia
ch'ia	qia
chih	zhi
cho	zhuo
chuan	juan
ch'uan	quan
ho	he
hsi	xi
hsia	xia
hsiang	xiang
hsieh	xie
hsien	xian
hsiung	xiong
hsuan	xuan
jan	ran
jen	ren
jih	ri
jou	rou
ka	ga
kai	gai
pa	ba
p'a	pa
pai	bai
pi	bi
ta	da
t'a	ta
tao	dao
te	de
tsa	za
ts'a	ca
tsai	zai
ts'an	can
tsang	zang
tsung	zong
ts'ung	cong
tzu	zi
yu	you
yung	yong

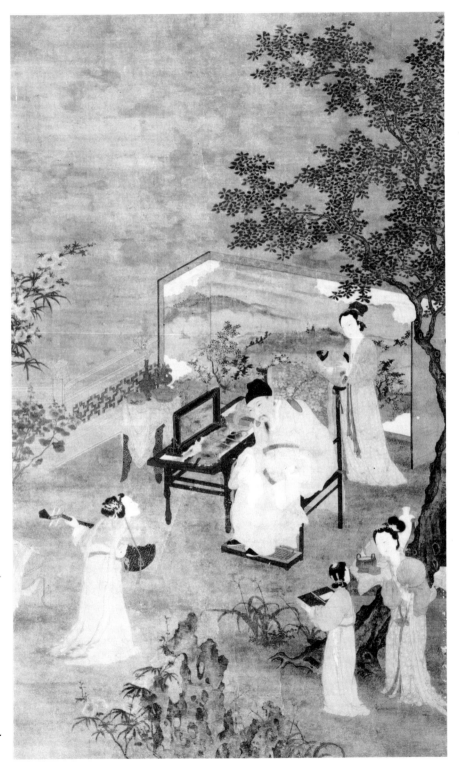

Tao Gu and Qin Ruslan. Hanging Scroll. Ink and colours on silk.

Bibliography

How to Paint the Chinese Way Jean Long, Blandford Press, 1979.

Chinese Ink Painting Jean Long, Blandford Press, 1984.

The Art of Chinese Calligraphy Jean Long, Blandford Press, 1987.

The Chinese Theory of Art Lin Yutang, Heinemann Press, London 1967.

The Mustard Seed Garden Manual of Painting, translated and edited by Mai-mai Sze, Vintage Books, Bollingen series 1956, second reprint 1978.

The Way of the Brush Fritz von Briessen, Charles E. Tuttle Co. Inc 1962 (revised 1975).

A Complete Guidance to Flower and Bird Painting Choy Kung Heng, Wan Li Book Co, 1974

Outline of Chinese Symbolism and Art Motives C.A.S. Williams, Dover Publications Inc. 3rd revised edn, 1976

Chinese Couplets T.C. Lai, Swindon Book Co. Hong Kong, 1969.

Handbook of Chinese Horoscopes Theodora Lau, Souvenir Press Ltd, 1979.

Imperial Chinese Art LinYutang, Omega Books 1983.

Tao Te Ching Gia-Fu Feng and Jane English, Wildwood House 1973.

Index